KLIMT

Catherine Dean

Phaidon Press Limited
Regent's Wharf, All Saints Street, London N1 9PA

Phaidon Press Inc.
180 Varick Street, New York, NY 10014

www.phaidon.com

First published 1996
Reprinted 1998, 1999, 2001, 2002, 2003
© 1996 Phaidon Press Limited

ISBN 0 7148 3377 0

A CIP catalogue record for this book is available from the
British Library

Printed in Singapore

The publishers would like to thank all those museum authorities and
private owners who have kindly allowed works in their possession to be
reproduced. Particular acknowledgement is made for the following:
Plates 3, 6, 7, 13, 15, 26, 29, 33, 34, 36 and 39: AKG, London; Plates 4
and 42 and Figs. 15, 18, 30 and 35: Verlag Galerie Welz, Salzburg;
Plates 9 and 17 and Fig. 24: private collection, courtesy of Galerie St
Etienne, New York; Plate 10: Bank Austria, Vienna; Plate 12:
Metropolitan Museum of Art, New York, Catherine Lorillard Wolfe
Collection; Plate 18: Sächsische Landesbibliothek Dresden, Deutsche
Fotothek; Plate 24: National Gallery of Canada, Ottowa; Plate 25:
reproduced by courtesy of the Trustees of the National Gallery,
London; Plate 27: Galleria Nazionale d'Arte Moderna, Rome, courtesy
of the Ministro per i Beni Culturi e Ambientali; Plate 37 and Fig. 37:
Modern World Art Collection, Národni Galerie, Prague; Figs. 1 and 26:
Bilderarchiv der Österreichischen Nationalbibliothek, Vienna; Fig. 23:
given by Janet Hubbard Stevens in memory of her mother, Janet
Watson Hubbard, courtesy of the Museum of Fine Arts, Boston;
Fig. 27: Museum of Modern Art, New York, Mr and Mrs Ronald S
Lauder and Helen Acheson Funds, and Serge Sabarsky, reproduction
© 1995 Museum of Modern Art, New York.

Note: All dimensions of works are given height before width.

Cover illustrations:
Front: *The Kiss*, 1907–8 (Plate 36)
Back: *Music I*, 1895 (Plate 5)

KLIMT

Klimt

Klimt's painting *The Kiss* (Plate 36) is one of the most famous images made in the twentieth century. Frequently reproduced in poster or greetings-card form, it encapsulates love in a single, beautiful image. The rapt face of the woman, the protective adoration of her lover and their oblivion to everything else portray a perfect love with universal resonance; it is hardly surprising that the painting has become so popular. While Klimt's fame can largely be attributed to his preoccupation with the major themes of life, love, motherhood and death, he is also admired for his magnificent decorative landscapes, erotic drawings and portraits of some of the great figures of his time.

Klimt's work has been widely reproduced for a number of reasons. Firstly, since his artistic career was quite short and his painted *œuvre* numbers only about 230 works, it is easy to include a good range of his paintings in a book. Secondly, his works tend to emphasize their own two-dimensionality and so they reproduce very well, even on a much reduced scale, despite the difficulties of photographing the gold paint so frequently used in his works. Finally, Klimt worked in a distinctive style which was popularized and widely disseminated at the time by the Viennese Secession and Workshop, the artistic groups to which Klimt belonged. Indeed, the Viennese Workshop was one of the first companies deliberately to make use of brand awareness to sell its goods, and the distinctive and familiar style of its products aided Klimt's rise to fame.

Klimt lived through some of the most exciting decades in the arts, with his home city of Vienna seeing extraordinary developments in art, architecture, music, literature and psychology. His contemporaries included Sigmund Freud and Gustav Mahler. Since Klimt was painting at the turn of the century, his work reveals the influence of both nineteenth- and twentieth-century ideas. As he developed, he reacted against the existing standards and expectations of the day, not without a certain centennial fervour, conscious of the end of an era. At the same time he grappled with many of the questions that have taxed twentieth-century artists and critics, including the consciousness of the painting as a two-dimensional representation of reality, created by form and colour, echoing the visible world in some respects, distant from it in others. He was also engaged in the debate about the artist's role as mediator of society and, more generally, about the freedom of the artist. Klimt was also an innovator: his use of gold paint and applied ornament, his experimentation with the square format for his works and his concept of the room as a decorative whole all point to an original, enquiring mind.

Although much is known about Klimt's life, it is difficult to form a clear impression of the artist's character. Klimt made a determined attempt to focus attention on his works, rather than on himself, feeling, it seems, that his paintings were much more interesting than his personality:

I have never painted a self-portrait [forgetting the scene of *The Globe Theatre in London*, part of the ceiling decorations for the staircases of the new Burgtheater in Vienna, see the commentary for Plate 1]. I am not interested in myself as the subject of a picture. I prefer other people, especially women, and, even more, other forms of existence. I'm not sure that I'm particularly interesting as a person. There is nothing special about me ... I have the gift of neither the spoken nor the written word ... For this reason people must do without an artistic or literary self-portrait ... Whoever wants to know something about me – as an artist, the only notable thing – ought to look carefully at my pictures and try to see in them what I am and what I want to do.

These words could hardly be more true. Klimt's numerous postcards sent to family and friends, say nothing much about his emotions or his art. He complains about his health – he was a bit of a hypochondriac – and comments very little on the works of art he saw on his few European travels: 'Spain and Moll [the painter Carl Moll (1861–1945), with whom he went to Paris and Madrid in 1909] wholly unsuited to nocturnes', is typically brief. The best account of his daily life comes from the recollections of Emil Pirchan (1881–1957), an architect, painter and set designer:

His ordinary working day was that of a respectable citizen, healthy and regular. Before six o'clock in the morning, he made a pilgrimage on foot to Tivoli near Schönbrunn; his friend the photographer Max Nähr [Moriz Nähr] accompanied him in his 'morning prayers' for 30 years. Once arrived, they ate a substantial breakfast at the farm. Then he took a coach back to his studio in Josefstädterstrasse, impatient to start work. The studio was very simple, its only decoration being pictures resting on their easels. But in front of this simple house giving on to a courtyard there was a little garden in which Klimt planted his favourite flowers for use as models. Six, eight and more cats lived there and as he could not bear to part with any of his animals, from time to time they had to be disposed of secretly, because the pack increased at such a rapid rate and had damaged more than one picture [see Fig. 1]. Klimt worked all day until dark; he spent most of his evenings in the company of friends. He was very generous with money and willingly gave to those who asked for help.

Gustav Klimt was born in 1862 in Baumgarten, one of Vienna's suburbs, the second of seven children born to Ernst, an engraver and goldsmith, and Anna. The family came from the Austrian capital's liberal middle class, a group anxious to further its children's careers through education. However, the Klimt family were not at all well off and frequently had to move in order to find cheaper accommodation or to avoid paying backdated rent. At the age of 14, after seven years in the local school, Klimt was sent, with a grant from the state, to the Vienna School of Arts and Crafts, which was attached to the Royal and Imperial Austrian Museum for Art and Industry. Like the Victoria and Albert Museum in London (then called the South Kensington Museum), the Austrian Museum aimed to be more than just a showcase for the best in art and design. Its purpose was to educate, not merely via the visual display of its collection, but also through practical and theoretical teaching. Klimt may well have been motivated by the thought that at least he would probably be able to earn a living after

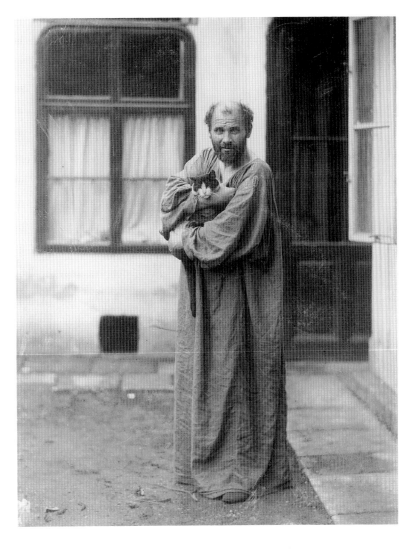

Fig. 1
MORIZ NÄHR
Klimt in a painter's
smock, with a cat, in
front of his studio at
21 Josefstädterstrasse
in Vienna
c1912. Photograph.
Österreichische
Nationalbibliothek,
Vienna

graduating by working as a drawing teacher, or in industry.

Klimt's talents developed under the tutelage of Ferdinand Laufberger (1829–81) and Victor Berger (1850–1902), both established artists who had carried out lucrative public commissions. The teaching style was highly traditional, with lectures on perspective, technique and style, lessons in drawing from plaster casts and rigorous copying of original paintings; the point of art education was to learn from past masters. One great artistic movement was thought to be followed, logically and inexorably, by another. This approach, now known as Historicism, was criticized by some for its reliance on copying, for the lack of freedom it allowed artists and for failing to move with the times. The emphasis on craftsmanship combined with the regard for what they perceived as good taste did, however, provide artists of Klimt's generation with a solid grounding in many different techniques and an in-depth knowledge of the history of art, and Klimt used this to his advantage.

After only three years at the Vienna School of Arts and Crafts, Klimt was able to make money through his art, selling portraits for six guilders each. In 1879 he began to work more seriously on commercial projects. With his brother Ernst (1864–92) and another student, Franz Matsch (1861–1942), Klimt founded the Artists' Company. One of their first commissions was to make the decorations (designed by Laufberger, their tutor) for the pageant organized to celebrate the silver wedding of the Emperor Franz-Josef and the Empress Elizabeth in 1879. They also carried out the decoration of the Court

Museum of Art History, the home of the imperial art collections, again following Laufberger's designs. The eight spandrels and three panels assigned to Klimt were to cover the history of art from Ancient Egypt to Renaissance Florence. Klimt spent much time studying the extensive art collections of the Viennese museums for both reference and inspiration. Motifs from Egyptian and Classical Antiquity were a particular favourite and recur in Klimt's art throughout his career, but he also continued to look to the works of the Old Masters. The permission-to-copy book at the Kunsthistorisches Museum in Vienna shows Klimt's signature on 28 April 1885, requesting permission to make a copy in oils of *Isabella d'Este*, by Titian (*c*1487–1576).

This practical experience led to further commissions to produce four allegories for the ceiling of the house belonging to the architect Stuarany in Vienna and a ceiling painting for the Thermal Baths in Carlsbad. By 1881 Klimt was working on illustrations for the book *Allegories and Emblems* published by Martin Gerlach (see *Love*, Plate 3 and *Finished Drawing for the Allegory of Tragedy*, Plate 6). At the same time he was collaborating with Ernst and Matsch on another interior decoration job for the house of the composer Ziehrer, in Vienna, this time using designs by Berger. In 1882 the threesome gained their first commission in theatre decor: a collaboration with the architects Fellner and Helmer, who specialized in theatre design and decoration, on the ceiling paintings and curtain for the municipal theatre of Liberec, now in the Czech Republic. In 1883, having completed his studies at the Vienna School of Arts and Crafts, Klimt set up a studio with his partners. It is a sign of the financial success they had already achieved that they were able to afford to rent one. Their previous experience in the Artists' Company led to many further commissions for various theatre decoration projects, ceiling paintings in private houses and portraits of the Romanian royal family.

There were frequent opportunities for work. Between about 1860 and 1900 Austria experienced a set of political, economic and social crises that combined to produce an enthusiastic market for the arts. Austrian society, with its ruling aristocracy and predominantly agricultural economy, was not receptive to industrialization and as a result the Vienna stock market crashed in 1873. (Ironically, Vienna was hosting the World Fair that year.) After this the middle classes lost any say they had previously had in political affairs and, when the strident demands of the working classes brought about the formation of the Christian Social Democrats and the Socialists, the middle classes turned their attention to art, music and literature instead. Historians have also suggested that Austria's lack of significant military victories abroad meant that national pride was diverted towards the arts. Certainly the extravagance and splendour of the imperial silver-wedding festivities would seem to confirm this.

Vienna's appearance itself was changing. During the 1850s the old city's fortified walls had been demolished and the glacis, a stretch of open ground just outside the walls that had been used to exercise the troops, was transformed into a wide boulevard, called the Ringstrasse, circumnavigating the city. The next 30 years saw building on an unprecedented scale. Some 150 public buildings – including a church, Parliament house, town hall, stock exchange, university, theatre and museums – and 650 private houses, blocks of flats and hotels were erected. With each new home owner eager to outdo his neighbour, there were tremendous possibilities for architects, designers and decorators.

Klimt's big breakthrough came in 1886 with another theatre project, the ceiling decorations for the staircases of the new Burgtheater (see

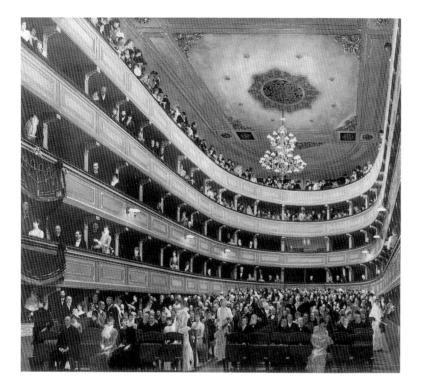

Fig. 2
Auditorium of the Old
Burgtheater
1888. Gouache on paper,
82 x 92 cm. Historisches
Museum der Stadt Wien,
Vienna

Plate 1), finished two years later. This project was to be particularly significant. The Ringstrasse era was one of great optimism, in which the middle classes were playing – and were seen to be playing – an important role. Projects such as the decoration of the new Burgtheater gave them ample opportunity to express their aspirations. Scenes of Graeco-Roman drama, painted with great attention to costume, design and ornament, allowed nineteenth-century audiences to make direct comparisons with their own age, and to see themselves as the natural successors to past glories. Indeed, in 1887 the Viennese City Council commissioned Klimt and Matsch to paint a gouache of the interior of the *Auditorium of the Old Burgtheater* (Fig. 2) before it was demolished to make way for the new theatre. Klimt used family and friends as models for the painting as a way of saving money on professionals; his brother Ernst is standing in the third row from the front on the left-hand side. However, part of the commission was to include in the painting recognizable portraits of 150 members of Vienna's middle-class society among the audience. Here, the bourgeoisie could see itself playing its role as a culturally élite audience, shaping dramatic history. So realistic are the near-photographic portraits that Klimt was commissioned by several people depicted in the audience to make copies of the painting. Following the success of this work, the Emperor awarded Klimt the Gold Cross for artistic merit. The award made his name in society and, although he encountered opposition throughout his career, this early recognition of his talent clearly smoothed his path.

Klimt's style, which had begun to diverge from that of his partners during the work on the Burgtheater, lost more of its traditional academicism when, in 1891, he became a member of the leading artists' organization in Vienna, the Co-operative Society of Austrian Artists. Nonetheless, Klimt stuck with his partners and in 1892 they were able to afford to move to a bigger studio. Sadly, in December of that year the death of Klimt's father was closely followed by that of his brother, Ernst. This did not immediately break up his partnership with Matsch, and consolation for the pair – at least in financial terms – came in the form of a commission from the Ministry of Education for

Fig. 3
Reconstruction by
Alice Strobl of the
planned sequence of
the Faculty Paintings

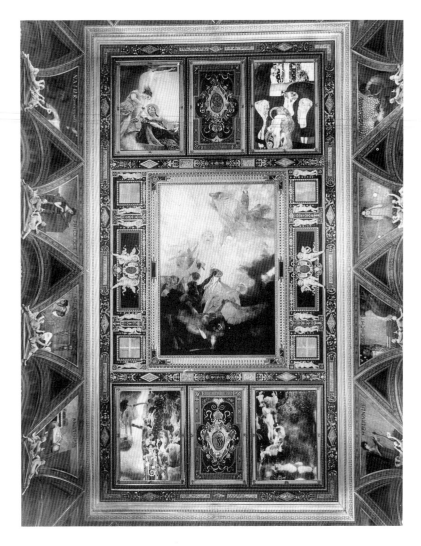

allegorical ceiling paintings for the Great Hall of Vienna University, the so-called Faculty Paintings. The theme of the Faculty Paintings was to be 'The Victory of Light over Darkness'. Klimt was given the subjects of philosophy, medicine and jurisprudence, while Matsch worked on theology (see Fig. 3). During 1893, while continuing work on other decorative projects, he and Matsch studied the layout and proportions of the spandrels and ceiling panels that were to contain the paintings, and in the following year their designs were accepted. They did not begin the actual paintings until 1897, but the exhibition of the sketches at the Co-operative Society of Austrian Artists provoked controversy long before then. This manifested itself as early as December 1893, when the Academy of Fine Arts proposed that Klimt be appointed professor at the Master School of History Painting, but the Emperor chose someone else. Despite winning the Gold Cross and despite the importance of the commissions he was receiving (in 1895 Klimt won a prize in Antwerp for the decoration of the auditorium of the Esterhazy Palace in Totis, which he had begun in 1893), Klimt was already too radical an artist. Naturally, he was disappointed at this first hitch in the relatively smooth progress in his chosen career up to that point. In 1894 Matsch moved out of their joint studio, and the Artists' Company gently dissolved, although the two still worked together on the designs for the Faculty Paintings.

The enforced exile of the middle classes from political power was balanced, to some extent, by a number of cultural revolts. The literary circle 'Young Vienna' was one of the first groups to derive its identity from its stance against traditional literary norms. Artistic revolt came in

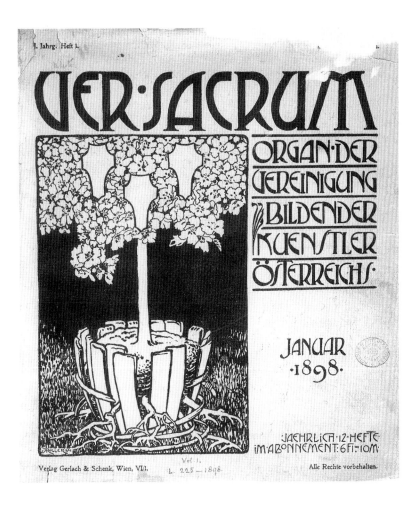

Fig. 4
ALFRED ROLLER
Cover for the first
issue of *Ver Sacrum*
1898. Lithograph,
30 x 29 cm.

1897, when a group of artists broke away from the Co-operative Society of Austrian Artists to form a group, chaired by Klimt, called the Viennese Secession. The name refers to the ancient Roman *secessio*, whereby disaffected Romans would move onto one of the seven sacred hills of Rome and threaten to establish a second Rome unless their demands were met. The Secession's magazine, first published in 1898 (and continuing to appear until 1903), was named *Ver Sacrum*, a reference to the Roman practice during troubled times of offering a sacrifice of everything born during a particular spring. When the children born during that spring reached adolescence, they would leave their home town to found a new community elsewhere. The use of these two Roman terms, *secessio* and *Ver Sacrum*, was intended as a deliberate distancing device from the Medieval and Renaissance periods so beloved of the Historicists, while being appropriately oedipal in origin. In addition to the general criticisms of Historicism, the Secessionists had felt frustrated by the lack of attention paid to modern European art in general. They did not intend to cut themselves off from the Co-operative Society of Austrian Artists completely, but by publishing a letter to the Society in the Press they caused such offence that a complete break was inevitable. The cover of the first issue of *Ver Sacrum* (Fig. 4) was designed by Alfred Roller (1864–1935), one of the journal's editors. The magazine included the statutes of the Secession, or the Association of Austrian Artists as they formally called themselves:

1: The Association of Austrian Artists has made it their task to promote purely artistic interests, especially the raising of the level of artistic sensitivity in Austria. 2: They aim to achieve this by uniting Austrian artists both in Austria and abroad, by seeking fruitful

contacts with leading foreign artists, initiating a non-commercial exhibition system in Austria, promoting Austrian art at exhibitions abroad, and by making use of the most significant artistic achievements of foreign countries both to stimulate art in our own country and to educate the Austrian public with regard to the general development of art.

It is easy to infer from this statement the problems – as the Secessionists saw them – with the *modus operandi* of the Co-operative Society of Austrian Artists. They rebelled against the insularity of the Viennese art establishment, against organizing exhibitions purely for commercial gain – which frequently denied contemporary artists the chance to exhibit – and against the Historicists' view of the history of art.

In *Ver Sacrum*, which was published every month during the first two years of its existence and then on a fortnightly basis, the editors successfully endeavoured to combine typography and illustration to create a unified look, in which the individual elements were subordinated to the greater whole. Included were reproductions both of members' works and contemporary European art, photographs of exhibitions, examples of alphabets and typefaces, decorative vignettes, poetry, essays, critical pieces and musical compositions. In addition to the ordinary version of the journal, there was a de luxe edition, which appears to have been done largely by hand, since there are significant differences in colouring from one copy to another.

In order to redress the problems of the art scene of the day, in the spring of 1898 the Secession organized the first of its important and influential exhibitions. Klimt designed the poster (Fig. 5) which depicted a naked Theseus, under the aegis of Athene the goddess of wisdom, fighting the Minotaur: it is an allegory of the Secessionists' fight against the old-fashioned Historicists. The exhibition, which included 131 works by foreign artists and only 23 by Viennese painters, was honoured by a visit from the Emperor. This imperial endorsement no doubt contributed to the exhibition's success: there were 57,000 visitors, around 40 per cent of the 534 paintings were sold, and, of these, 10 were bought by the government. The official banning of Klimt's poster also created much publicity for the Secession.

The financial success of their first exhibition, together with support from a few wealthy patrons, enabled the Secessionists to mount a second show in November of the same year, held in the association's own Secession building. It was designed for them by the architect Joseph Maria Olbrich (1867–1908). Classical in inspiration, the white building was topped by a gilded dome of wrought-iron laurel leaves. Above the entrance were the words: 'To Each Age its Art, to Art its Freedom'. Critics had a field day, heaping a rich variety of insults on the Secession building: 'Mahdi's tomb', 'a gilded cabbage', 'a cross between a greenhouse and a blast furnace' and 'an Assyrian public lavatory'. The last comment was particularly insulting, as the large, wealthy Jewish population of Vienna were historically hostile to the Assyrians. But Olbrich's aim, to create a gallery which would complement the exhibits, was admirably realized. He was the first to use sliding walls to create changing spaces that would best suit the works of art on show. More importance was placed on the individual work and, at the same time, the attention given to the exhibition as a harmonious whole created a total work of art in which the sum was greater than its parts.

The Secessionists' artistic reform programme coincided with a period of favourable political conditions. Von Hartel, the Minister for

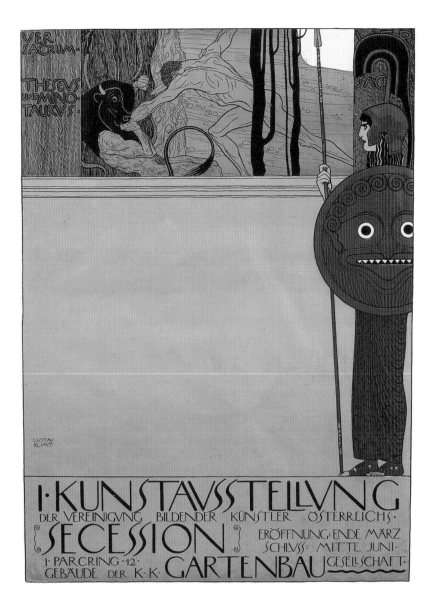

Fig. 5
Poster for the First
Viennese Secession
(censored version)
1898. Lithograph,
64 x 47 cm. Historisches
Museum der Stadt Wien,
Vienna

Education who founded the Arts Council in 1899, expressed views closely related to those of the Secession. They themselves were appointed to key positions in the art world in an almost mafia-like infiltration of art officialdom. The architect Otto Wagner (1841–1918) was an influential member of the Academy of Fine Arts; Wagner and Alfred Roller belonged to the Arts Council; Roller was stage designer at the Court Opera House; the painter Baron Felician von Myrbach (1853–1940) initiated extensive reforms at the Vienna School of Arts and Crafts (which Klimt had attended); and Secession members such as Josef Hoffmann (1870–1956), Koloman Moser (1868–1918) and Arthur Strasser joined the Vienna School of Arts and Crafts. Historicism was on the way out. In 1900 a Civil Servants' government was formed and for a few years Austrian artistic policy was liberalized considerably, resulting in the state's promotion of contemporary European art. Both the Arts Council and the Modernist Gallery (Moderne Galerie), first proposed at the Arts Council's opening meeting and founded in 1903, were state institutions. However, the Modernist Gallery was soon transformed into the Royal and Imperial Austrian State Gallery, which showed not just contemporary art but also Austrian art of all periods – a transformation symptomatic of the patriotic fervour sweeping Austria in the first decade of the twentieth century.

Fig. 6
Philosophy
(first version)
1894–1900. Medium and
dimensions unknown.
Destroyed by fire at the
Schloss Immendorf in
1945

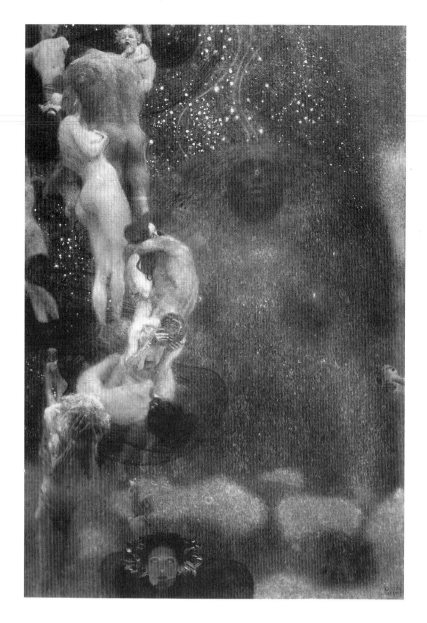

In 1900, at the seventh Secession exhibition, Klimt exhibited the first version of *Philosophy* (Fig. 6), one of the Faculty Paintings he had been commissioned to produce for Vienna University. Klimt was wary of showing the preparatory version (the final work was not completed until 1907), however, the Secession committee had announced its inclusion in the show and had reserved a prominent place for it in the first room of the exhibition. The painting shows a group of figures on the left, ranging from children at the top to a decrepit old man at the bottom. On the right is a sphinx-like head, suggesting that only with the aid of philosophy or knowledge, represented by the female head at the bottom of the picture, can one make sense of the world. *Philosophy* was immediately criticized for its mysterious, allegorical imagery, which was at odds with the academics' perception of themselves as rational beings. Not only do the figures have no recognizable aim, worse, the painting illustrates a widely held idea of the period (although it was unpalatable to the academics): that the purposeful progress of history was ultimately governed by incomprehensible and uncontrollable cyclical forces of nature. An open protest letter was signed by 11 professors, while the Rector of the University issued a press statement saying that philosophy was based on the exact sciences. Even when the painting was taken to the World Fair in Paris later that year, where it was awarded a prize, the furore continued.

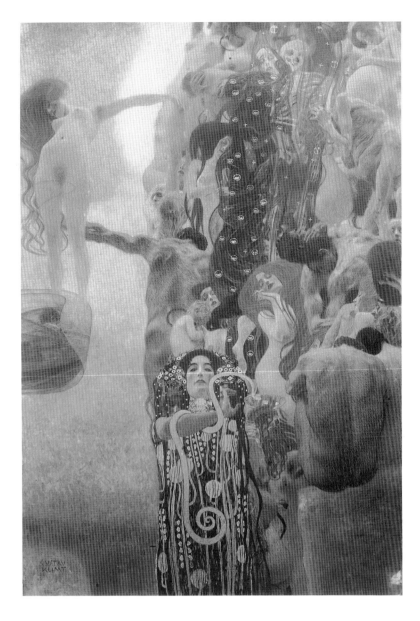

Fig. 7
Medicine
1900–7. Oil on canvas,
430 x 300 cm. Destroyed
by fire at the Schloss
Immendorf in 1945

When *Medicine* (Fig. 7), the second of the Faculty Paintings, was exhibited in 1901, it met with similar opposition. Critics were particularly enraged by the pessimistic view of medicine that they believed it displayed, commenting that the painting depicted birth, sickness and death and not the healing and preventative powers of medicine. The female figure at the bottom of the composition represents Hygeia, the Greek goddess of medicine, but to Klimt's detractors she seemed to have little to do with the rest of the picture. Furthermore, the naked female figure floating free of the others provoked accusations of pornography. Indeed, the affair became so serious that the whole story of the Faculty Paintings was debated in Parliament and the commission eventually had to be reconfirmed. None of this helped Klimt in terms of official recognition and acceptance. In 1901, when his name was put forward a second time for a professorship, he was again turned down, clearly due to the controversy over the Faculty Paintings.

After the death of his brother in 1892, Klimt maintained contact with Ernst's widow Helene and more particularly with her sister, Emilie Flöge. From 1897 onwards, for two or three months every summer, Klimt and Emilie would go off with the Flöge family to Salzkammergat in the foothills of the Austrian Alps. These breaks from city life provided Klimt with the opportunity for painting

Fig. 8
Forester's Lodge in
Weissenbach at Lake
Atter
1912. Oil on canvas,
110 x 110 cm. Private
collection

landscapes, as well as walking, exercising, rowing on the lake and reading. Between 1897 and 1902, a particularly difficult time for Klimt as has been seen, he painted no less than 15 landscapes, a remarkable output considering the slow pace at which he habitually worked. No doubt landscapes were intellectually less demanding than other genres, but the fact that they eventually amounted to a quarter of his *œuvre* would seem to confirm the sense of relaxation and renewal that Klimt experienced during his rural retreats. In letters and postcards to family and friends Klimt frequently writes about his desire to escape city life. He continued to paint sunlit views of the country cottage in which the Flöge family stayed, farms, lakeside villages, flowers, trees and forests until his death. Unpopulated apart from the rare animal or bird, Klimt's landscapes seem to have embodied a sort of Arcadian ideal for the artist, in which the only activity is the indiscernible growth of the plants.

Most of Klimt's painting in Salzkammergat was done in the open air in front of his chosen scene, but then finished in the studio. Hardly any drawings of landscapes exist; perhaps they were all lost in 1945 in the fire which destroyed Emilie's apartment, where many of his sketchbooks were kept, or perhaps he simply did not make preparatory sketches for these works. He used an ivory viewing-frame to establish the composition and then binoculars to focus on the details of the landscape. The employment of these devices led to a telescoped and flattened view of the scenery – a close-up of nature, rather than a prospect. Klimt's landscapes look like other painters' interiors, corresponding with his expressed desire to retreat 'into' the countryside, rather than to survey it from a lofty and distant height. The square format he invariably adopted adds to the stillness of the composition. The lines of the lawn, path, window panes and roof in *Forester's Lodge in Weissenbach at Lake Atter* (Fig. 8), for example, lock together the disparate elements of the composition, allowing Klimt to paint exuberant masses of foliage while maintaining stability. The

Fig. 9
Avenue in Schloss
Kammer Park
1912. Oil on canvas,
110 x 110 cm.
Österreichische Galerie,
Vienna

landscape genre also provided Klimt with a relative freedom to experiment. Released from the requirement to present a faithful portrait of a sitter, he was able to explore decorative effects for their own sake, such as patterned mosaic-like tree trunks and leaves, and reflections in water. He would also place the horizon high up the composition or even remove it altogether, further flattening the picture plane.

Some of Klimt's rural views, such as *The Sunflower* (Fig. 30), appear to be more than just landscapes. *Avenue in Schloss Kammer Park* (Fig. 9) is also more than it first appears. Klimt painted the Schloss several times, but always from the lake, apart from this one. He clearly enjoyed playing with symmetry and asymmetry in his choice of viewpoint, so that avenue, door and windows are all off-centre. It has also been suggested that this particular view is charged with sexual connotation, given the shape of the framing trees around the red and black door, with whorls of foliage above.

While in the countryside, Klimt took a series of photographs of Emilie, sometimes with himself, wearing dresses that she and her sisters sold in their own women's clothes shop. These pictures are affectionate, yet Klimt's relationship with Emilie has never really been understood. Many things point to their apparent intimacy: the summers spent together in Salzkammergat; Klimt's last words, 'I want Emilie to come'; and the fact that Klimt bequeathed his sketchbooks to Emilie. Yet other factors seem to imply that the two were not so close as all that. They never married and Klimt continued to live at home with his mother and sisters. Despite sending numerous postcards to Emilie there is not a single word of love in them, bar the use of an affectionate nickname, 'Midi', whereas he certainly sent love letters to other women. Although Klimt and Emilie saw each other almost daily when they were back in Vienna, this left plenty of time for affairs. Klimt slept with many of his models and girls from the poorer suburbs of Vienna. When he died several women began

Fig. 10
Jurisprudence
1900–7. Oil on canvas,
430 x 300 cm. Destroyed
by fire at the Schloss
Immendorf in 1945

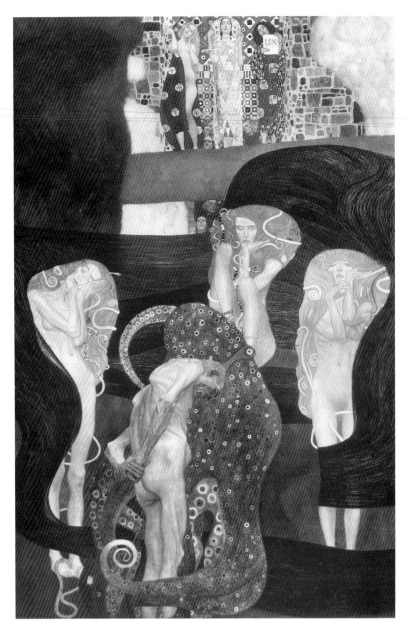

Fig. 10
Jurisprudence
1900–7. Oil on canvas,
430 x 300 cm. Destroyed
by fire at the Schloss
Immendorf in 1945

paternity suits to establish that he was the father of their children, allegedly 14 in total. In the event, four cases were upheld.

The fourteenth Secession exhibition, held in 1902, was particularly important for Klimt and must have done much to restore his confidence in Vienna's artistic life. The centrepiece of the show was a statue of Beethoven by Max Klinger (1857–1920). The composer was represented as more god than mortal, with references to biblical and Classical mythology. As Olbrich had intended, it was possible to remodel completely the interior of the Secession building so that other artists' paintings and sculptures complemented Klinger's statue. A temple-like atmosphere was achieved; even the formal layout of the exhibition created a reverential feel, with its three church-like aisles. The idea of harmonizing all the elements within the Secession exhibition to create an artistic and decorative whole was particularly important to the group. This is hardly surprising given their belief in the legitimacy and value of crafts, their experience in interior and theatre decoration, and the composition of the association itself, which was made up of painters, sculptors, architects and designers. Klimt's contribution was in the form of a mural, known as the Beethoven Frieze (Fig. 25 and Plates 19–22), which ran around the top of three walls of the first room in the exhibition. The exhibition was

extraordinarily successful, receiving 58,000 visitors, due in no small part to Beethoven's enormous popularity.

The following year, at the eighteenth Secession exhibition, Klimt showed the last of his three Faculty Paintings, *Jurisprudence* (Fig. 10). At the top of the canvas in the background are three female figures representing Justice, Law and Truth, while behind them are the seemingly decapitated heads of judges. The old man in the foreground, head bowed and entwined by an octopus's tentacles, represents the victim, accused by the three naked females. It is conceivable that Klimt was thinking of his own position while creating this work. Not surprisingly, the critics hated it as much as *Philosophy* (Fig. 6) and *Medicine* (Fig. 7). These first two paintings were stylistically related but the later one looked entirely different, with its simpler and bolder colours and technique, thus giving Klimt's detractors additional cause for complaint. Furthermore, Klimt's representation of Jurisprudence is plainly not optimistic; rather, he sees the law as vengeful, focusing on crime and punishment. The debate raged on. The Ministry refused to cancel the commission but offered to hang the paintings in a museum rather than install them in the Great Hall. However, they did refuse to lend them for the World Fair exhibition in St Louis in the United States. Finally, in 1904, Klimt announced that since his artistic freedom was being constrained by an undeserving public, he was returning all advance payments and that he was keeping the works still in his possession. In view of the amount of official patronage Klimt had received earlier in his career, such a break was all the more dramatic.

Luckily, Klimt found enough to occupy him in the way of private commissions, ensuring that the loss of public work did not matter financially. He was also free to experiment with new artistic techniques and materials. The artists and craftsmen of the Secession were developing the idea of the total work of art, and they delighted in producing not only the paintings with which to furnish a room, but also designs for the furniture, soft furnishings and even the house itself. However, the members of the Secession discovered that there were few craftsmen with the skills needed to carry out their designs and few shops in which to sell the objects. In 1903, therefore, Josef Hoffmann and Koloman Moser established the Viennese Workshop, inspired by the ideals and example of the critic John Ruskin (1819–1900), the painter William Morris (1834–96), the architect and designer Charles Rennie Mackintosh (1868–1928) and the Arts and Crafts Movement. The Viennese Workshop was closely associated with the Secession and many members belonged to both groups. They carried out commissions in all types of materials, producing glassware, ceramics, gold and silver jewellery, metalwork, textiles, fashion, furniture and graphic design. In practice, contrary to their democratic ideals, the Viennese Workshop's products were too expensive for all but the wealthiest sections of society.

In 1905 Klimt had the opportunity to try out the skills developed in the Viennese Workshop, following their idea of a unified approach to architecture and interior decoration. Adolphe Stoclet, an industrialist, commissioned Josef Hoffmann to design a luxury family house, known as the Palais Stoclet, in Brussels. Hoffmann attended to the smallest details, from light switches to door handles. Numerous other artists and craftsmen worked with him on the project. Klimt was commissioned to decorate the dining room with a frieze (Fig. 11), and the resulting mosaic of semiprecious stones, metals and glass is probably the most ornate of all his designs (Plates 30–2). The overall look of Klimt's Stoclet Frieze owes much to the Byzantine mosaics in

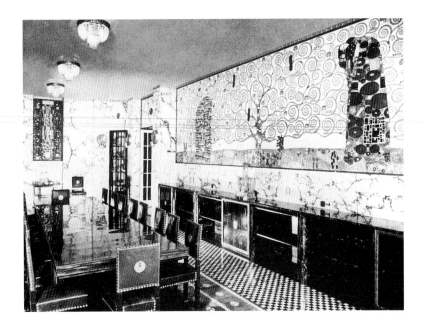

Fig. 11
Dining room in the
Palais Stoclet,
showing the frieze
and mosaics designed
by Klimt
Date unknown.
Photograph.

Ravenna. In 1903, only one year before the Stoclet commission, Klimt had made one of his rare trips abroad – a welcome escape, no doubt, from the troubles at home. Although he visited Florence, Padua and Venice, where he was very taken with the work of Vittore Carpaccio (*c*1460/5–1523/6), his principal destination was Ravenna, to see the mosaics.

With public commissions no longer forthcoming after the débâcle of the Faculty Paintings, Klimt looked to portraiture as a way of earning a living, and indeed became so sought-after that he was able to command high prices and had to turn away work. He had already made his name with his first important portrait, the *Portrait of Sonja Knips* (Fig. 12). It was shown at the second Secession show in November 1898, as its beaten-metal frame made by his brother Georg was not ready in time for the first exhibition in March of that year. Unlike his later commissioned portraits, which tend to emphasize his sitters' haughty distance, the one of Sonja Knips seems to make every effort to reveal her charm. The painting technique is soft, while the composition is divided diagonally so that the subject occupies only part of the picture space. This device was to reappear often in Klimt's portraits of the 1910s. Sonja Knips had had an ordinary black notebook specially bound in red leather which Klimt filled with sketches for her; she is shown holding the book in this painting. The soft pink of her dress provoked Ludwig Hevesi, a contemporary critic, to remark that 'Klimt sticks to no one line: he always takes new liberties, especially for his female portraits, where each has a different colour scheme and is painted with a differently disposed hand.' These were not formulaic works, then, but considered portraits, responding to the nature and character of the sitter – an essential ingredient for success. Several of Klimt's portraits, notably the one of Serena Lederer (Plate 12), show the influence of James McNeill Whistler (1834–1903), whose work Klimt much admired (Fig. 13). He later saw an exhibition of Whistler's work in London in 1906.

His sitters, exclusively female after 1899, came from the wealthy section of Viennese society and were almost always Jewish Austrians or Hungarians. They tended to shop at the Viennese Workshop, where they bought clothes, jewellery and furniture. Some of them lived in houses designed by Hoffmann. Klimt's portraits reflect the desire for unified art, ornament, interior decoration and architecture, combining for the first time naturalistic faces with patterned clothes

and settings. Despite Klimt's 'differently disposed hand', the decorative effect of these portraits tends to subvert the importance of the sitter herself, reflecting the status of women in early twentieth-century Viennese society. Klimt's commissioned portraits were invested with an eroticism more apparent than in the works of his contemporaries. Beneath the richly patterned costumes and rigidly constructed compositions is a sensual appreciation of femininity. The *Portrait of Baroness Elisabeth Bachofen-Echt* (Fig. 14), for example, shows the elongated figure of the Baroness, who was the daughter of Serena Lederer (Plate 12), her hands hanging exactly at crotch height. The two interlocking diamond shapes of her dress also lead our eye to this point. The images of Adele Bloch-Bauer (Plates 34 and 41) are also intimate portraits – she is the only society lady painted by Klimt who is known definitely to have been his mistress.

An inherent sexuality is even more evident in the mythological or biblical subjects he occasionally painted, such as *Judith I* (Plate 15) and *Judith II* (Plate 38). Judith's predatory nature must surely relate to Klimt's own view of the female sex, even if only subconsciously. Since he is known to have read very little, it is extremely unlikely that he had actually read the works of Freud, but the café society to which he belonged would no doubt have discussed the latest revelations. Where men appear in Klimt's late works, as in *The Bride* (Plate 48) or *Adam and Eve* (Fig. 15), they are shown concealing themselves behind women, in a drowsy, inactive stupor. They are certainly subordinate to the more powerful females, even though the women are reduced entirely to sex objects.

Meanwhile, the Secession was suffering from an identity crisis. It had begun to form into two groups: the Stylists, who worked in several media, like Klimt; and the Painters, who regarded themselves as purists. The Stylists achieved considerably more financial success than the Painters, being more adaptable and enjoying close links with the most important commercial gallery in Vienna, the Galerie Miethke. This was ironic, since the Secession had been founded partly as a result of its members' dislike of the commercial activities

Fig. 13
JAMES MCNEILL
WHISTLER
Symphony in Flesh
Colour and Pink:
Portrait of Mrs
Frances Leyland
1871–3. Oil on canvas,
195.9 x 102.2 cm. Frick
Collection, New York

of the Co-operative Society of Austrian Artists. In 1905 Klimt and 24 colleagues from the Secession resigned, splitting the two groups and leaving behind the Painters. The new Artists' Association, consisting of the former Stylists, has since become known more commonly as the Klimt Group. The Viennese Workshop remained independent but several of its members also belonged to the Klimt group. A more formal link between the two groups was eventually made in 1914 when one of Klimt's patrons, Otto Primavesi, rescued the Viennese Workshop from near bankruptcy under its then backer, Fritz Waerndorfer.

The withdrawal from the Secession meant that Klimt and his associates had nowhere to exhibit. They arranged various small shows in the Galerie Miethke, the salerooms of the Viennese Workshop and abroad, but it was not until 1908, when they were given the use of a plot of land near to the Ringstrasse, that Hoffmann was able to design and build a suitable exhibition space for the Klimt Group. The 1908 exhibition, which, like the following year's show, was called simply the Art Show Vienna, marked the sixtieth anniversary of the Emperor's accession to the throne. At the opening Klimt made a speech which clearly reveals his anger over the controversy surrounding the Faculty Paintings. The text of the speech was printed in the catalogue: 'Not that we regard the exhibition as the ideal way of establishing contact between an artist and his public: we would much prefer large-scale public commissions. But as long as the authorities continue to think in terms of commerce and politics, the only way open to us is the exhibition.' Only works of art by Austrian artists were exhibited, but these included arts and crafts, paintings and sculptures by amateurs and children, as well as professional artists and students from the Vienna School of Arts and Crafts, whose members included Oskar Kokoschka (1886–1980). Klimt was given a room to himself and showed 16 paintings, including *Water Snakes I* (Plate 26) and *Water Snakes II* (Private collection), *The Three Ages of Woman* (Plate 27), the portraits of Margaret Stonborough-Wittgenstein (Plate 28), Fritza Riedler (Plate 33), and Adele Bloch-Bauer (Plate 34), *Danaë* (Plate 35) and *The Kiss* (Plate 36). The Austrian Government immediately bought *The Kiss* for the state collections.

The 1909 Art Show Vienna displayed paintings by such great foreign artists as Henri Matisse (1869–1954), Paul Gauguin (1848–1903) and Vincent van Gogh (1853–90), as well as by younger Austrian artists. Kokoschka exhibited again, as, for the first time, did Egon Schiele (1890–1918). The architect Josef Hoffmann supposedly introduced Schiele to Klimt. Although Klimt was 28 years older than Schiele, the two became very close. When Klimt died, Schiele went to Vienna's General Hospital morgue to draw the artist's portrait, reporting that, as Klimt had been shaved upon dying, he found him much changed. Schiele himself died only eight months after Klimt, a victim of the influenza epidemic sweeping Vienna.

Expressionism was on the rise at this time. This was a movement in which artists attempted to articulate their inner feelings through exaggerated line and colour. Klimt appears to have felt somewhat outdated, saying: 'The young ones don't understand me any more. They're going somewhere else.' Yet his own work changed dramatically between the two Art Show Vienna exhibitions. He stopped using the gold and silver leaf that so characterized his work of the first years of the twentieth century and instead turned his attention to colour and texture. In 1909 he visited Paris, where he saw the work of Matisse and the Fauves, and also Madrid, where he

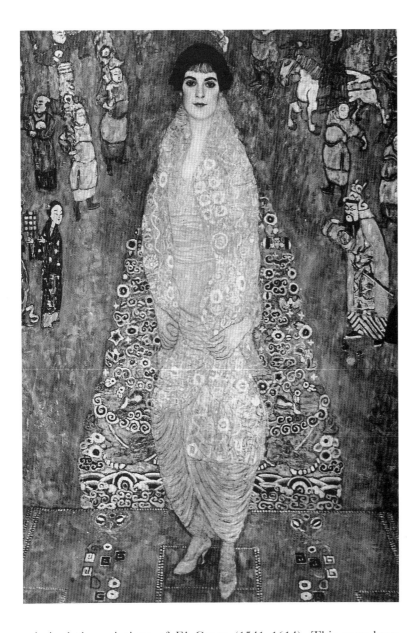

Fig. 14
Portrait of Baroness
Elisabeth Bachofen-
Echt
*c*1914. Oil on canvas,
180 x 128 cm.
Kunstmuseum, Basle

admired the paintings of El Greco (1541–1614). This may have inspired him to extend the range of his palette, but his work still bore no direct relation to that of any other painter. In 1911 Klimt went to Florence, Rome and Brussels and in the same year was forced to move, as the house in which his studio was located was demolished. He furnished the hall of his new home with Viennese Workshop furniture by Hoffmann and hung his collection of Japanese colour woodcuts and Chinese prints on the walls. Klimt's life after 1911 seems to have been fairly uneventful, although he did send works for exhibition abroad, including the ninth Venice Biennale in 1910. The advent of the First World War apparently had little effect on him. Vienna, which had been one of Europe's most civilized and colourful cities before 1914, certainly suffered during the war, with refugees, rationing and fuel shortages, but none of this is obvious from Klimt's writings or paintings.

On 11 January 1918 Klimt suffered a minor stroke while dressing. The damage was confined to paralysis of his right side, which was extremely grave since he painted with his right hand. However, just as he appeared to be making progress and some movement was returning to his arm he caught pneumonia – a by-product of the influenza epidemic then sweeping the city. He died on 6 February, less than a month after his initial illness. He was buried four days

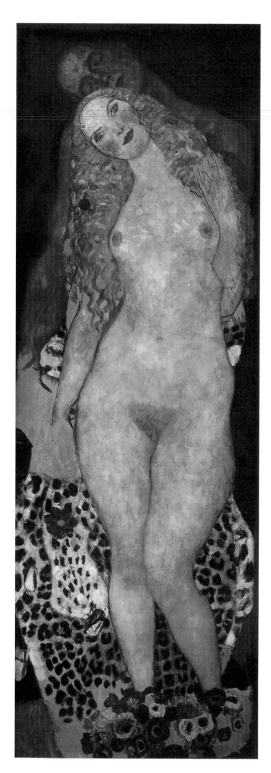

Fig. 15
Adam and Eve
(unfinished)
1917–18. Oil on canvas,
173 x 60 cm.
Österreichische Galerie,
Vienna

later in the Hietzing cemetery, in a grave donated by the state. The ceremony was attended by many eminent official representatives, which is ironic, considering their attitude towards Klimt while he was alive.

Looking back over the whole of Klimt's *œuvre*, what is most striking is the way in which he constantly returns to the same few subjects: landscapes, portraiture and allegorical or symbolic works. All but the first focus on women, and indeed it is only really by examining the actual works that we can learn much about Klimt himself, who was generally reticent.

Klimt's death brought to light the huge number of erotic drawings that he had produced throughout his career. Although a few sketches were shown at exhibitions and some were published in *Ver Sacrum*, it was not until the art dealer Gustav Nebehay organized a posthumous exhibition of some 200 of them in 1918 that anyone realized how prolific Klimt was; in total there were between 5,000 and 6,000 drawings, of which around 3,000 are known today. Many of these served as sketches for paintings and would therefore not have been for public consumption; others were done for his own collection, as a sort of private library. Contemporary accounts speak of Klimt needing to be able to break from working on a big painting by dashing off a sketch or two, noting that he always kept one or two models handy for when the urge took him. (Some accounts explain Klimt's relationship with Emilie Flöge as a sort of 'upstairs-downstairs' affair: downstairs were the models, laundresses and prostitutes with whom he had sex, while upstairs was the pure, chaste Emilie.) Early twentieth-century censorship seems not to have had a prohibitive effect. When an attempt was made to prosecute Klimt over the publication of drawings for *Medicine* (Fig. 7) in *Ver Sacrum*, the court disagreed, ruling that 'Whenever we are dealing with a serious work of art, purely governed by aesthetic considerations, it would be inappropriate to speak of an offence against people's sense of morality or modesty.'

Perhaps the key to Klimt's art lies in a passage of a book written in 1923 by the Austrian painter Anton Faistauer, who knew Klimt:

He is conceivable only in Vienna, better still in Budapest or Constantinople ... His entire spirituality is Oriental. Eros plays a dominant role, his taste for women is almost Turkish ... Persian vase decorations and Oriental rugs inspired him greatly ... Gold and silver on his canvases attracted him especially ... For the Western European Klimt is ... inaccessible and he is relegated to the category of arts and crafts by those who do not wish to deal with his uniqueness. With the exception of a few early influences at the time of the Secession's foundation – Khnopff, Toorop – Klimt never looked westwards and with the exception of a journey to Spain via Paris was never interested in Western culture. Klimt's personality was the same as his work ... He loved the good life and peace and quiet like a true Oriental and looked like one too.

Vienna, the westernmost point of the Ottoman Empire, was the only place in which Klimt could have found the rich variety of art and culture that shaped his work. 'Asia began at the Landstrasse', as Prince Metternich (1773–1859) famously observed. Although Klimt has no direct imitators in our century, the eclecticism of his sources, his willingness to experiment with new media and his concern with the total work of art all have their adherents today. In particular, Klimt's interest in craft, combined with his interest in fine art, has done much to reinvigorate the status of the artist-craftsman.

Outline Biography

1862 Gustav Klimt, the second son of Ernst and Anna Klimt, born 14 July.

1876 Enters the Vienna School of Arts and Crafts, with a grant from the state.

1879 Forms the Artists' Company with his brother Ernst and another student, Franz Matsch.

1880 The Artists' Company is commissioned to produce four allegories for the ceiling of Stuarany's house in Vienna and a ceiling painting for the Thermal Baths in Carlsbad.

1881 Works on illustrations for *Allegories and Emblems* (see Plates 3 and 6).

1882 Gustav, Ernst and Matsch work on theatre decor with the architects Fellner and Helmer. Klimt also works on the ceiling paintings and curtain for the municipal theatre of Liberec.

1886 Klimt begins work on the ceiling decorations for the staircases of the new Burgtheater in Vienna (see Plate 1).

1891 Becomes a member of the Co-operative Society of Austrian Artists.

1892 Deaths of Klimt's father and brother Ernst.

1893 Klimt and Matsch start work on the Faculty Paintings for Vienna University.

1895 Klimt wins prize in Antwerp for the decoration of the auditorium of the Esterhazy Palace in Totis.

1897 Foundation of the Secession with Klimt as elected president. Klimt resigns from the Co-operative Society of Austrian Artists.

1898 Klimt designs the poster for the first exhibition of the Secession; the first issue of its magazine *Ver Sacrum* appears. In November, the Secession's second exhibition is held.

1900 Although unfinished, Klimt's *Philosophy* (Fig. 6), the first of his Faculty Paintings, is awarded the gold medal at the World Fair in Paris.

1901 Widespread criticism in the Viennese Press of Klimt's Faculty Paintings. The subject is debated in Parliament.

1902 Exhibition of Max Klinger's statue of Beethoven in the Secession building. Klimt contributes a frieze (Fig. 25 and Plates 19–22).

1903 The Viennese Workshop is founded.

1904 Pays back his advance for the Faculty Paintings and reclaims them. Commissioned to produce cartoons for a mosaic frieze for the dining room of the Palais Stoclet in Brussels (Fig. 11 and Plates 30–2).

1905 The Secession splits into two factions; Klimt and his friends form the Klimt Group.

1908 *The Kiss* (Plate 36), shown at the first Art Show Vienna, is bought by the state.

1918 Suffers a stroke on 11 January and dies on 6 February.

Select Bibliography

Alessandra Comini, *Gustav Klimt*, London, 1975

Alice Strobl, *Gustav Klimt, Die Zeichnungen 1878–1918*, Salzburg, 1980–9

Angelica Bäumer, *Gustav Klimt, Women*, London, 1986

Johannes Dobai, *Gustav Klimt, Landscapes*, London, 1988

Gottfried Fliedl, *Gustav Klimt 1862–1918, The World in Female Form*, Cologne, 1989

T Stooss and C Doswald (eds.), *Gustav Klimt*, exhibition catalogue, Kunsthaus, Zürich, 1992

Wolfgang G Fischer, *Gustav Klimt and Emilie Flöge, An Artist and his Muse*, London, 1992

Gerbert Frodl, *Klimt*, London, 1992

Peter Vergo, *Art in Vienna 1898–1918, Klimt, Kokoschka, Schiele and their Contemporaries*, 3rd edition, London, 1993

Patrick Werkner, *Austrian Expressionism, The Formative Years*, Palo Alto, CA, 1993

Frank Whitford, *Gustav Klimt*, London, 1993

Christian M Nebehay, *Gustav Klimt, From Drawing to Painting*, London, 1994

Angela Völker, *Textiles of the Wiener Werkstätte 1910–1932*, London, 1994

List of Illustrations

Colour Plates

1 The Altar of Dionysus
(detail of the ceiling decoration)
1886–8. Oil on plaster. Burgtheater, Vienna

2 Egyptian Art I and II, Greek
Antiquity I and II
1890–1. Oil on plaster, spandrel h230 cm.
Kunsthistorisches Museum, Vienna

3 Love
1895. Oil on canvas, 60 x 44 cm. Historisches
Museum der Stadt Wien, Vienna

4 Hofburg Actor Josef Lewinsky as Carlos
1895. Oil on canvas, 64 x 44 cm.
Österreichische Galerie, Vienna

5 Music I
1895. Oil on canvas, 37 x 45 cm.
Neue Pinakothek, Munich

6 Finished Drawing for the Allegory
of Tragedy
1897. Black chalk with pen, washed, gold,
highlighted, 42 x 31 cm. Historisches
Museum der Stadt Wien, Vienna

7 Pallas Athene
1898. Oil on canvas, 75 x 75 cm. Historisches
Museum der Stadt Wien, Vienna

8 Quiet Pond in the Park at the
Schloss Kammer
1899. Oil on canvas, 74 x 74 cm.
Private collection

9 Flowing Water
1898. Oil on canvas, 52 x 65 cm.
Private collection

10 Mermaids
c1899. Oil on canvas, 82 x 52 cm.
Private collection

11 Nuda Veritas
1899. Oil on canvas, 252 x 56 cm.
Theatersammlung der Nationalbibliothek
Wien, Vienna

12 Portrait of Serena Lederer
1899. Oil on canvas, 188 x 85.4 cm.
Metropolitan Museum of Art, New York

13 Schubert at the Piano
1899. Oil on canvas, 150 x 200 cm. Destroyed
by fire at the Schloss Immendorf in 1945

14 Portrait of Joseph Pembauer
1890. Oil on canvas, 69 x 55 cm.
Tiroler Landesmuseum Ferdinandeum,
Innsbruck

15 Judith I
1901. Oil on canvas, 84 x 42 cm.
Österreichische Galerie, Vienna

16 Goldfish
1901–2. Oil on canvas, 150 x 46 cm. Dübi-
Müller Foundation, Kunstmuseum, Solothurn

17 Island in Lake Atter
c1901. Oil on canvas, 100 x 100 cm.
Private collection

18 Beech Forest I
c1902. Oil on canvas, 100 x 100 cm.
Gemäldegalerie Neue Meister, Dresden

19 The Longing for Happiness
(detail of the Beethoven Frieze)
1902. Casein paint on plaster, h2.2 m.
Österreichische Galerie, Vienna

20 The Forces of Evil
(detail of the Beethoven Frieze)
1902. Casein paint on plaster, h2.2 m.
Österreichische Galerie, Vienna

Text Illustrations

Comparative Figures

27 Hope II
1907–8. Oil on canvas, 189 x 67 cm. Museum
of Modern Art, New York

28 EGON SCHIELE
Water Sprites I
1907. Gouache, coloured crayon, silver and
gold paint on paper, 24 x 48 cm.
Private collection

29 JAMES TISSOT
A Portrait (Miss Lloyd)
1876. Oil on canvas, 91.4 x 50.8 cm.
Tate Gallery, London

30 The Sunflower
1906–7. Oil on canvas, 110 x 110 cm.
Private collection

31 Sitting Statue of Merimose
c1380 BC. Granodiorite, h69 cm.
Kunsthistorisches Museum, Vienna

32 Lower Half of an Egyptian Coffin
c1000 BC. Wood, linen, plaster, coloured
pigments and varnish, h120 cm.
Kunsthistorisches Museum, Vienna

33 Leda
1917. Oil on canvas, 99 x 99 cm. Destroyed by
fire at the Schloss Immendorf in 1945

34 The Black Feathered Hat
1910. Oil on canvas, 79 x 63 cm
Private collection

35 Apple Tree I
c1912. Oil on canvas, 110 x 110 cm.
Österreichische Galerie, Vienna

36 Embrace
1908. Pencil on paper, 55 x 35 cm.
Historisches Museum der Stadt Wien, Vienna

37 The Virgin
1913. Oil on canvas, 190 x 200 cm. Národni
Galerie, Prague

1 The Altar of Dionysus
(detail of the ceiling decoration)

1886–8. Oil on plaster. Burgtheater, Vienna

One of the Artists' Company's early commissions was to decorate the ceiling of two staircases in the new Burgtheater, one of the most important buildings in the Ringstrasse development. This was a prestigious job: the theatre company had the best reputation in the German-speaking world. The Viennese took their theatre-going seriously and part of the payment came in the form of free season tickets.

There were to be ten paintings in all, on the development of theatre from Antiquity to the Baroque – a theme chosen by the Burgtheater's director, Adolf von Wildbrandt. The three artists, Gustav and Ernst Klimt and Franz Matsch, drew lots to see who would paint each scene. Klimt was responsible for five paintings, which he carried out between 1886 and 1888: *The Altar of Dionysus*, *The Theatre of Taormina*, *The Altar of Apollo*, *The Thespian Cart* and *The Globe Theatre in London*, which contains the only self-portrait that Klimt ever painted.

Klimt turned to Vienna's museums for reference and inspiration, and his eclecticism is apparent in the finished scenes. *The Altar of Dionysus* shows an obvious debt to the works of two British painters very much in vogue in the late nineteenth century, Sir Lawrence Alma-Tadema (1836–1912) and Frederic, Lord Leighton (1830–96). The static quality of the poses, the way in which the figures are seen largely in profile (reminiscent of Classical friezes), the tight painting technique, the attention to drapery and the colouring all bear witness to the impact of these Victorian painters on Klimt's style (see Fig. 16).

The Burgtheater paintings were a great success, admired for their technical virtuosity, their ingenious compositions, and for the artists' painstaking research. Further, the verisimilitude allowed viewers to imagine that they were seeing the past as it had actually looked, and therefore to identify themselves with the great Classical tradition of theatre. Vienna in the 1890s could safely and surely be regarded as the natural and worthy successor to Graeco-Roman civilization.

Fig. 16
FREDERIC, LORD
LEIGHTON
Winding the Skein
1878. Oil on canvas,
100 x 161 cm. Art Gallery
of New South Wales,
Sydney

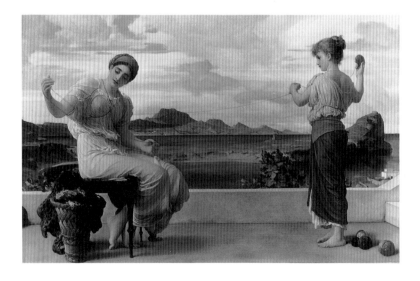

Egyptian Art I and II, Greek Antiquity I and II

1890–1. Oil on plaster, spandrel h230 cm. Kunsthistorisches Museum, Vienna

Another early commission for Klimt and his partners also came about as a result of the Ringstrasse development. As with the Burgtheater, the new decorations for the Court Museum of Art History, now known as the Kunsthistorisches Museum, were intended to display the splendour of imperial patronage. The actual programme for the decorations, comprising 13 paintings in all, was drawn up by Albert Ilg, the curator of the applied arts collection of the museum. He chose cycles of paintings that referred to highlights in the development of art: ancient Egypt and Greece, the Roman and Venetian Quattrocento, and the Italian Renaissance.

The artists had been told to study carefully examples of Antique art in the museum's collection and to adhere to the principles of Historicism. These examples clearly show Klimt's attention to detail. He has personified each tradition and given them the attributes of their era and style. The areas to be painted above the doorways made for awkward shapes, but Klimt and his companions solved the compositional problem deftly. This was the last major project that the three worked on together; Klimt's brother died in December 1892.

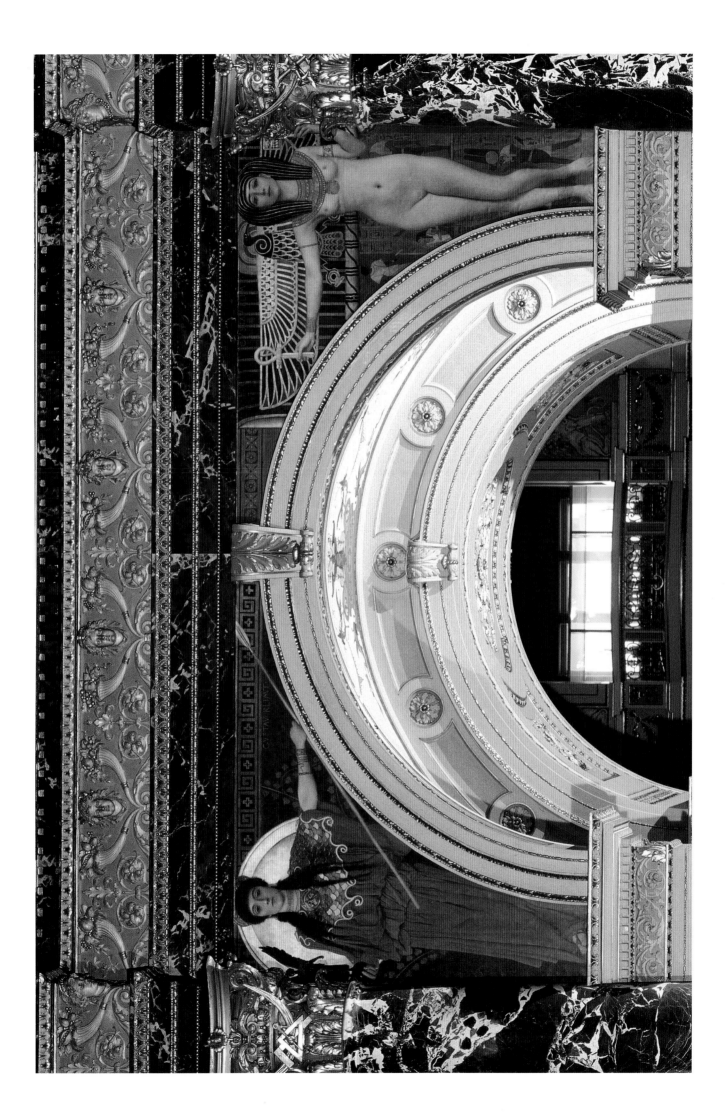

3 Love

1895. Oil on canvas, 60 x 44 cm. Historisches Museum der Stadt Wien, Vienna

36

Klimt's second portfolio of work for Gerlach's *Allegories and Emblems* included a representation of Love, for which this painting was the model. Rather than a simple depiction of a pair of lovers, Klimt has broadened the context to include a wider picture of the world. The two central figures, who are almost like actors on a stage, are watched by female heads personifying youth, old age and death, symbolizing the inexorable transitoriness of life and love. In many of his subsequent paintings, Klimt used the female figure in this allegorical and symbolic fashion.

A striking development in Klimt's work is seen here for the first time: the use of the frame. Nearly half of the picture is made up of the wide, painted frame on either side, creating a picture within a picture. Klimt has painted onto it naturalistic roses, which serve as a prelude to the painting proper, in that they provide a visual link between the realistic treatment of the figures and the flat colour of the frame. The roses' beauty and their romantic associations also allude to the lovers themselves.

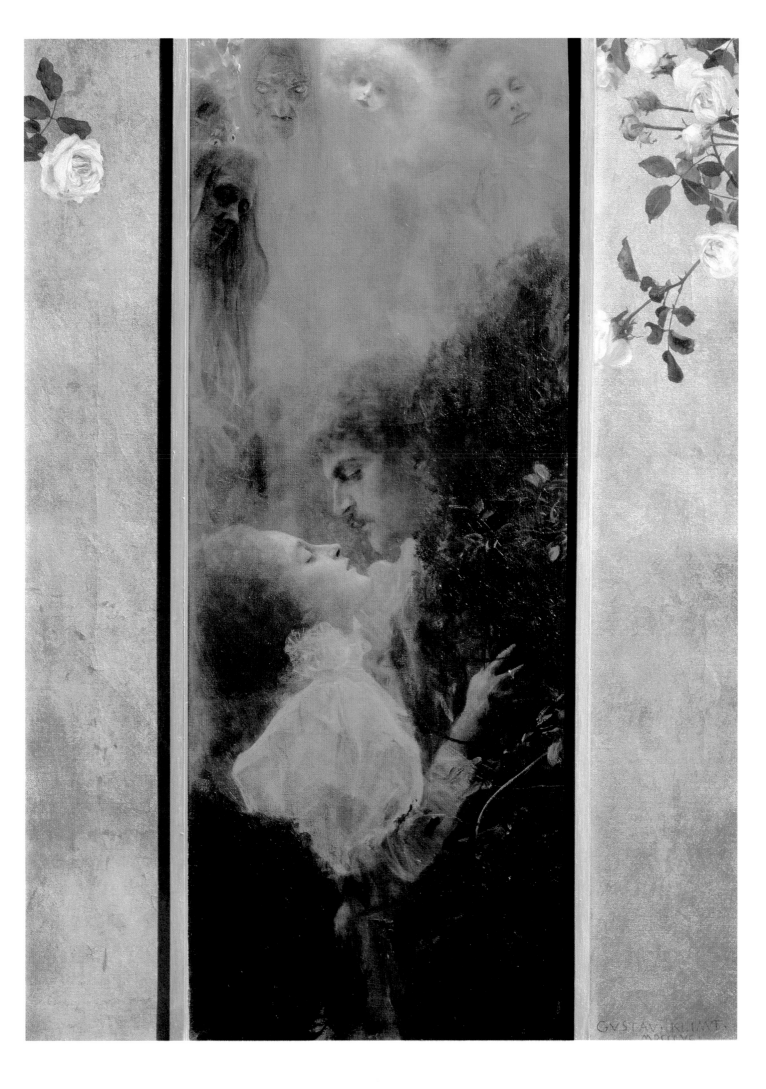

Hofburg Actor Josef Lewinsky as Carlos

1895. Oil on canvas, 64 x 44 cm. Österreichische Galerie, Vienna

As the title engraved in the gold panel at the top indicates, this portrait, like *Love* (Plate 3), also includes an allegory – that of theatrical spectacle. The self-conscious pose of the actor, the girl on the right holding the mask, and the third, gargoyle-like head all remind us that this portrait is a staged presentation of the subject, who is posed and framed for our perusal.

Like *Love*, this portrait makes use of the frame to comment further on the principal subject. A formal tension is set up by the contrast between the frame and its painted surface; the stylized image of the sacred Delphic tripod and the realistic depiction of Lewinsky; the decorative leaves and the shadows they appear to cast; and the three heads – living, mask and statue. The combined effect is to make the viewer question what is real; however good a likeness a portrait is, it can never be more than a series of overlapping coloured brushstrokes.

The use of lettering within the painting itself appears in several of Klimt's subsequent works: the *Nuda Veritas* (Plate 11), the *Portrait of Joseph Pembauer* (Plate 14) and *Judith I* (Plate 15). This was related to Klimt's preoccupation at that time with graphic design and printing; sketchbooks from the 1890s reveal his experiments with alphabets and typography.

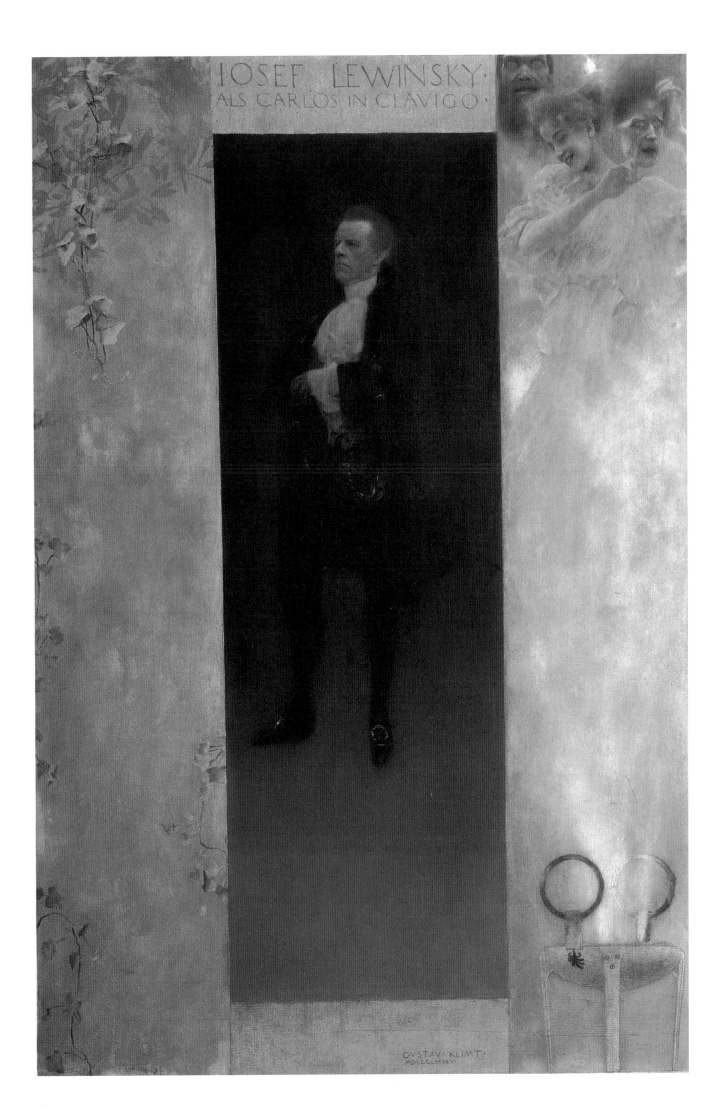

Music I

1895. Oil on canvas, 37 x 45 cm. Neue Pinakothek, Munich

This small canvas was Klimt's first exploration of the subject of music and was a preparatory study for one of a pair of paintings commissioned by Nicholas Dumba, an industrialist living in Vienna (see also *Music II*, Fig. 22 and *Schubert at the Piano*, Plate 13). The finished works were to hang in the panelling above the doors of the music room, hence their musical theme.

By 1895 Klimt was anxious to establish his own style and we see here a not entirely successful attempt to make his mark by marrying different motifs and methods. The lyre is borrowed from vase designs from Classical Antiquity. In contrast to the two-dimensional appearance of the lyre, the sphinx-like figure on the right-hand side is modelled in a realistic manner. The sphinx was a popular motif among artists of the time, with its enigmatic and ambiguous connotations. According to the Classical myth, the Sphinx lived just outside the city of Thebes and she devoured anyone who could not answer her riddles as a punishment for the crime committed by Laïos: he kidnapped the son of Pelops, with whom he had taken refuge, and thereby brought a curse on his own family. Only Oedipus, his son, answered the Sphinx correctly and thus saved his own life but killed his father. Klimt's contemporary, Sigmund Freud, made the story one of the central tenets of his writings and it seems likely that some of the impetus to paint the subject came from these philosophical enquiries.

During the early 1890s, when Klimt was a member of the Co-operative Society of Austrian artists, the organization had arranged various exhibitions of works by contemporary European artists. One of these was the Belgian Symbolist, Ferdinand Khnopff (1858–1928). His work impressed Klimt enormously. In 1898, three years after Klimt had painted *Music I*, Khnopff was invited to take part in the first Secession exhibition. Among the 20 works he showed was *The Sphinx* (Fig. 17). The sphinx appears in other paintings by Klimt – *Music II* (Fig. 22) and *Philosophy* (Fig. 6) – and in each case it represents a symbolic test of man's knowledge.

Fig. 17
FERDINAND KHNOPFF
The Sphinx
1896. Oil on canvas,
50.5 x 150 cm. Musées
Royaux des Beaux-Arts de
Belgique, Brussels

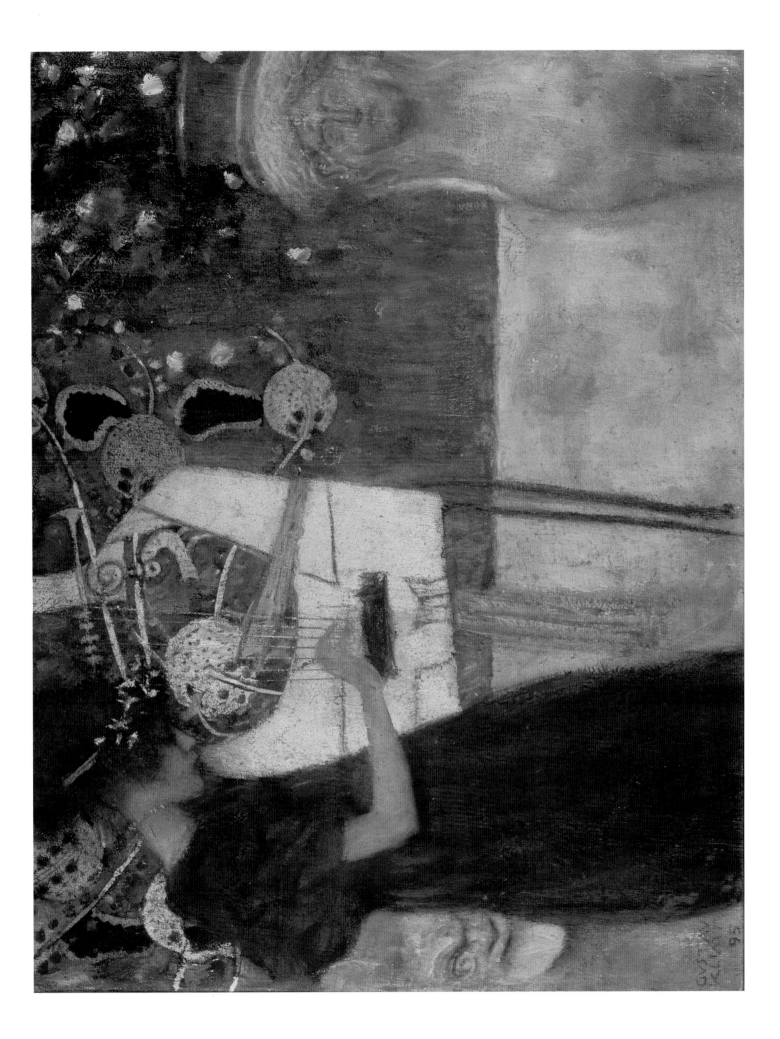

Finished Drawing for the Allegory of Tragedy

1897. Black chalk with pen, washed, gold, highlighted, 42 x 31 cm. Historisches Museum der Stadt Wien, Vienna

Like *Love* (Plate 3), this work was created for Gerlach's luxury book, *Allegories and Emblems*. It displays many of the characteristics already seen in Klimt's work: the realistically modelled central figure, surrounded on three sides by a wide frame with stylized female figures and ornament; motifs from different cultures, such as the Classical capital in front of the central figure, the small silhouettes behind her head derived from Antique vases and the Chinese dragon; the use of the mask, in this case a head with a bulging-eyed, open-mouthed stare, similar to the head in the *Hofburg Actor Josef Lewinsky as Carlos* (Plate 4); lettering within the picture space; and the use of gold to highlight certain areas. The hooped earrings mirror the 'O' in the word above, encouraging the viewer to look for other repeated circles and patterns in the drawing.

A key element in Klimt's catalogue of motifs makes its first appearance in this work – the heavy, ornate neckband. Reused to great effect in *Judith I* (Plate 15) and *Portrait of Adele Bloch-Bauer I* (Plate 34), the neckband serves to isolate the head from the body. Here, we are led to consider the contrast between the 'living' female and the mask she holds.

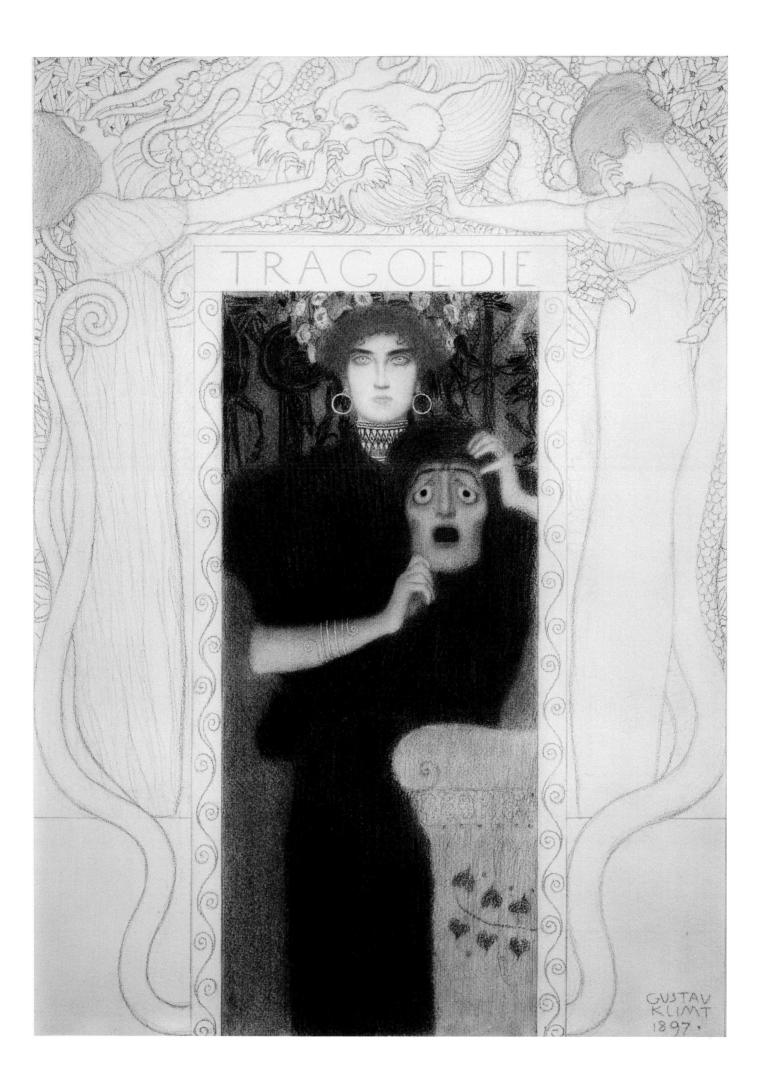

Pallas Athene

1898. Oil on canvas, 75 x 75 cm. Historisches Museum der Stadt Wien, Vienna

The Pallas Athene was a monumental statue outside the Parliament building in Vienna. The Secession adopted this Historicist icon as their patron, as had Franz von Stuck (1863–1928), a painter from Munich, as the emblem of the Munich Secession. She appears on the poster for the Secession's first exhibition (Fig. 5), designed by Klimt himself.

Klimt also painted a separate picture of the Pallas Athene, closely based on the statue in Vienna. Rather than emphasizing the Pallas Athene's historical significance, Klimt dwells on the figure's sensual allure. She is not some remote icon from the past but a seductive red-haired beauty, and her intended physical similarity to contemporary Viennese women further invites identification with the viewer. Another *femme fatale* is the tiny figure of Nike, or Victory, who makes an appearance under a different guise in *Nuda Veritas* (Plate 11); Pallas Athene holds her in one hand as if she were a small statue. Athene's ornate breastplate carries a Medusa mask, while behind her are profiles drawn from Attic black-figure vases. Klimt took note of the dark and light flesh tones used to differentiate male and female figures on these vases, and reproduced them when he painted *Adam and Eve* (Fig. 15). Surprisingly, when the painting was exhibited at the second Secession exhibition in 1898, most of the Press chose to criticize the nosepiece, despite its being an accurate copy from the Antique. No mention at all was made of the Nike figure.

The frame of *Pallas Athene* was produced by Klimt in collaboration with his brother Georg. Like their father, Georg, a sculptor, was skilled in metalwork and made this frame in embossed copper. Along the top is the name of the goddess and the painting's title and on either side are ornamental spirals, echoing the work on her breastplate.

The painting's square shape is an important innovation. From 1898 onwards, Klimt experimented with compositional devices offered by this format, usually thought to be difficult in terms of being able to achieve both balance and interest. Athene's elbow, bent at right angles, her symmetrical pose and square shoulder-piece, and the Nike's straight, outstretched arms are all offset by the slanting vertical of her spear, the only unstable element in the composition. The *Portrait of Sonja Knips* (Fig. 12) from the same year is also square in format but is divided diagonally so that the portrait occupies half of the canvas and the rest is left almost blank.

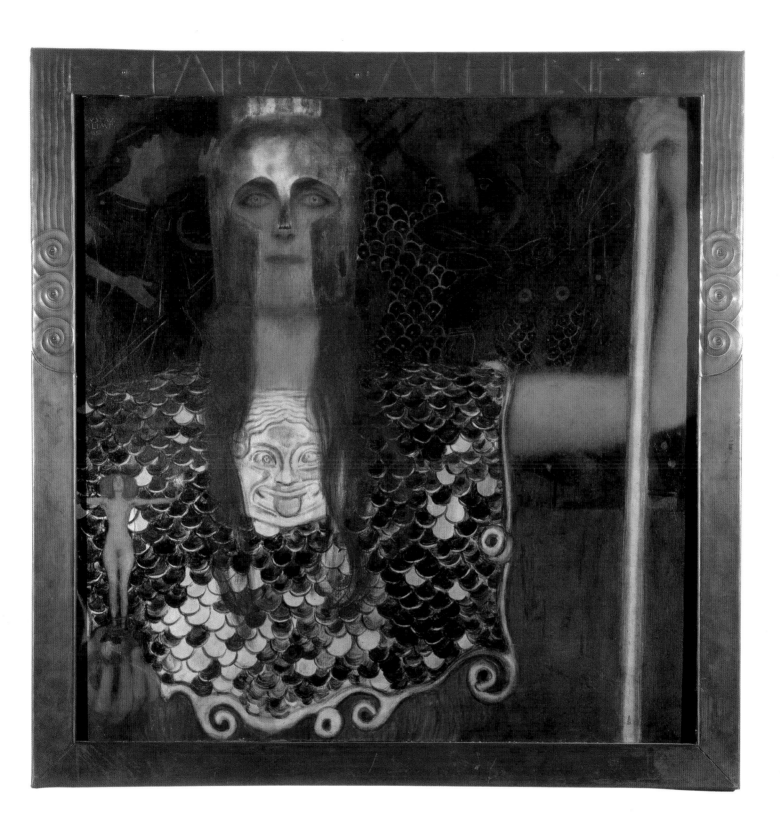

1899. Oil on canvas, 74 x 74 cm. Private collection

Fig. 18
After the Rain
1899. Oil on canvas,
80 x 40 cm.
Österreichische Galerie,
Vienna

Klimt's first four landscapes, painted during the summers of 1898 and 1899, share the portrait format of *Love* (Plate 3) and the *Hofburg Actor Josef Lewinsky as Carlos* (Plate 4). *After the Rain* (Fig. 18) is typical of these, with its atmospheric, muted tones. Klimt seems to have felt a sort of meditative peace in the countryside, contemplating the natural organic cycle of growth and decay. These unpopulated scenes are far removed from Klimt's turbulent city life at the time, when the furore over the Faculty Paintings was raging.

The tree trunks in *After the Rain* are cut off by the upper edge of the painting. This compositional device, which tends to flatten the trees and transform them into mere patterns, was perhaps inspired by the contemporary interest in *Japonisme*. In any event Klimt returned to the motif many times in his landscapes, as in *Beech Forest I* (Plate 18).

The high horizon is reminiscent of many landscape paintings by Whistler, an artist whom Klimt much admired (see Figs. 13 and 21). The new square format, adopted by Klimt after his first few landscapes, lent itself to a very low or high horizon, as here. While Klimt does not follow the rules of the Golden Section, the more traditional method of proportion (which divides an area in two so that the lesser is to the greater as the greater is to the whole, a proportion that works out at roughly 8:13), his canvases achieve a stability that ensures a sense of timelessness far removed from the Impressionists' attempts to record the fleeting passage of time.

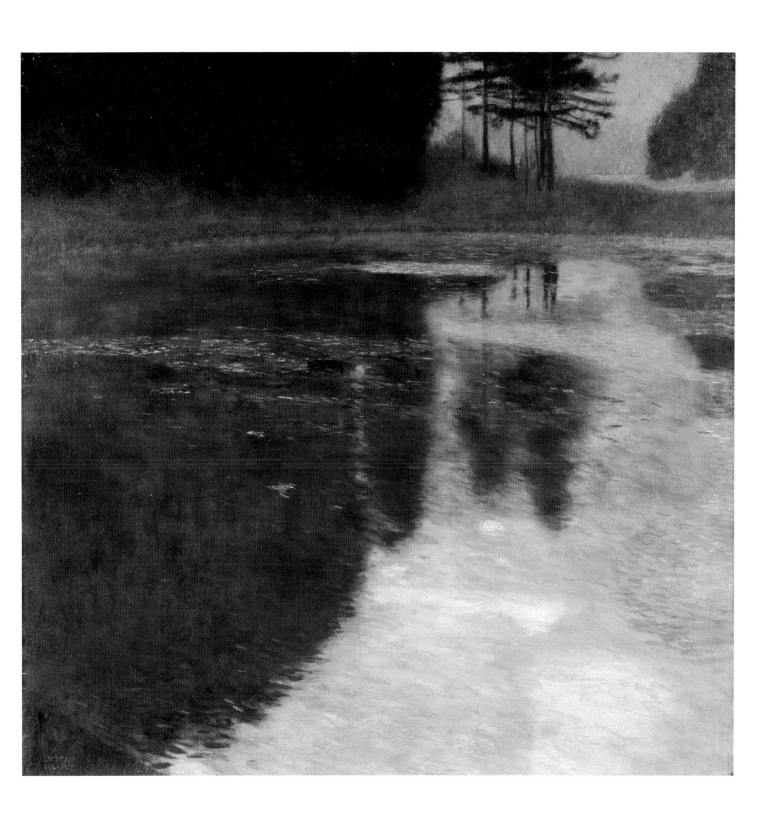

1898. Oil on canvas, 52 x 65 cm. Private collection

Fig. 19
Fish Blood
1898. Pen and ink on
paper, 29.8 x 28.8 cm.
Historisches Museum der
Stadt Wien, Vienna

Klimt's paintings of women in water are overtly sensual. The flow of water around their curvaceous bodies is depicted as a sort of erotic caress, as their abandoned poses indicate. Hair is also heavily sexualized in Klimt's works, as it was in contemporary Vienna, and the women's trailing tresses reinforce the eroticism of the work. In the bottom right-hand corner of the painting is a bulging-eyed male head, which gazes at the female figures above with voyeuristic intent.

The painting clearly derives from Klimt's pen and ink drawing *Fish Blood* (Fig. 19), which was reproduced in the third issue of *Ver Sacrum*. Klimt seems to have enjoyed working in pen and ink; quite possibly the absence of colour allowed him to concentrate on the composition. Like the *Portrait of Sonja Knips* (Fig. 12) painted the same year, it is divided diagonally from bottom left to top right, this time with the subject occupying the top half of the canvas. Klimt painted a tiny sprig of flowers in the top left-hand corner of the portrait, which acts to stabilize that area of the composition. Here, however, he has been able to leave the bottom right-hand corner completely empty, bar his signature, without upsetting the balance. The fish on the bottom left-hand side reappears in *Goldfish* (Plate 16). Two later paintings by Klimt, *Water Snakes I* (Plate 26) and *Water Snakes II* (Private collection) also explore the sensual theme of women in water; indeed they are also known as 'Girlfriends I' and 'Girlfriends II'.

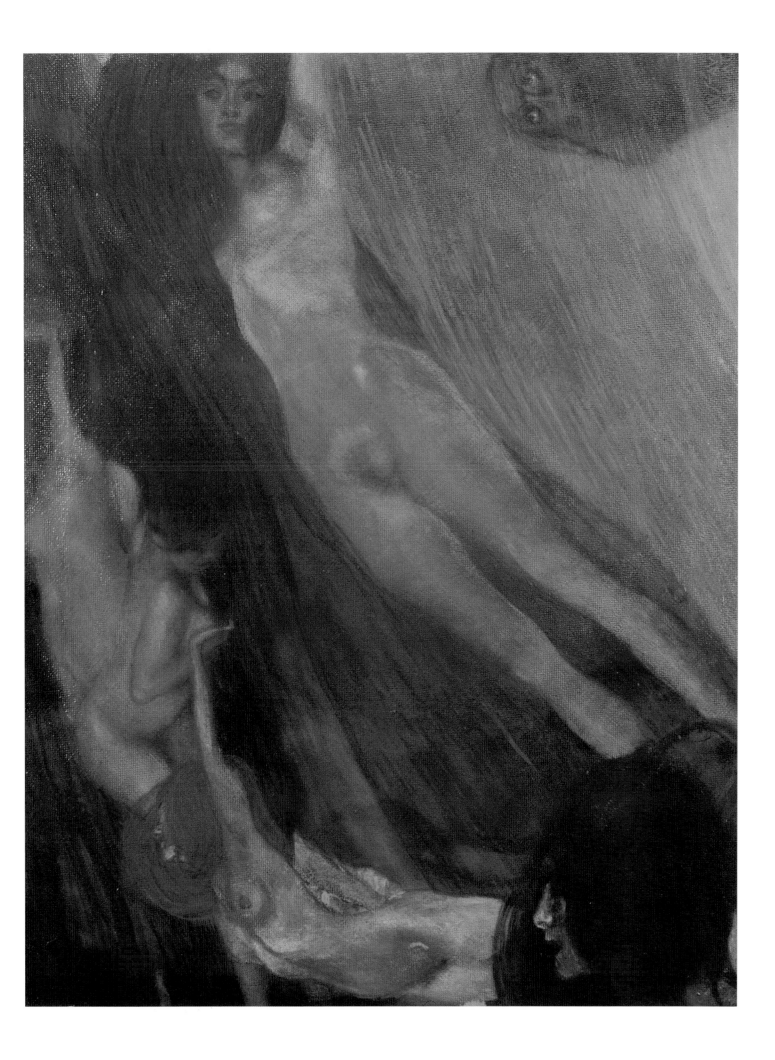

10 Mermaids

*c*1899. Oil on canvas, 82 x 52 cm. Private collection

50

Like *Flowing Water* (Plate 9) this is another work dwelling on the sensuality of water and the female body. *Mermaids* looks forward to one of the Faculty Paintings, *Jurisprudence* (Fig. 10), on which he began work the following year. The sheath-like nature of the female figures' hair and the surprisingly phallic outline of their bodies are strikingly similar. Furthermore, even the colouring must have been broadly comparable. Since the Faculty Paintings were destroyed in a fire in 1945, we have only the notes of the contemporary art critic Ludwig Hevesi to tell us that 'black and gold predominate in *Jurisprudence*'. The rather menacing, predatory nature of these mermaids, with their strongly emphasized eyes, brows and mouths, suggests that they are to be viewed as sirens or *femmes fatales*. The male voyeur present in *Flowing Water* has – perhaps wisely – gone away.

Hair forms an erotic element in nearly all of Klimt's paintings of women, with heavy tresses concealing or revealing the body. Klimt rarely hesitated to show pubic hair, even in his 'public' commissions, at a time when other Europeans such as the British were only just getting over their Ruskinian alarm at such detail. While *Fish Blood* (Fig. 19) shows the traditional undivided crotch, *Flowing Water* shows a clear, if fuzzy, patch of red hair. The same distinction occurs between the drawing for *Nuda Veritas* (Fig. 20) and the finished work (Plate 11). The most shocking of all appearances of pubic hair is in *Hope I* (Plate 24), where the combination of pregnancy and red pubic hair outraged Viennese society.

Nuda Veritas

1899. Oil on canvas, 252 x 56 cm. Theatersammlung der Nationalbibliothek Wien, Vienna

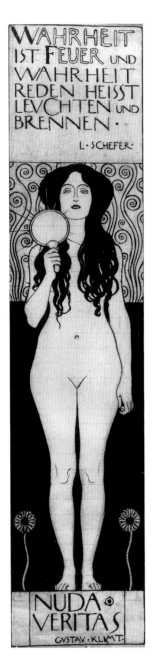

Fig. 20
Drawing for *Nuda Veritas*
1898. Black chalk, pencil, pen and ink on paper, 41 x 10 cm. Historisches Museum der Stadt Wien, Vienna

The text from the German poet Schiller at the top of the painting reads: 'If you cannot please everyone with your actions and your art, you should satisfy a few. To please many is dangerous.' The somewhat aggressive note of this inscription, combined with the mirror that the female figure holds out to the viewer, inviting us to examine ourselves, can perhaps be related to the rebelliousness of the Secession movement.

The text also reveals the elitism of the Secessionists, in that only a small and select circle could understand and appreciate their ideas. The figure of *Nuda Veritas*, or 'naked truth', is not intended to be the mediator of the Secessionists' beliefs. Instead, the emphasis on her femininity encourages the viewer to think of her as a desirable woman, rather than as an allegorical figure. Although the viewer is being presented with 'the truth', only those privileged enough to grasp the tenets of the Secession can benefit from the figure of truth.

A finished drawing for the *Nuda Veritas* (Fig. 20) was published in the Secessionists' journal, *Ver Sacrum*. The essentials of the composition are the same, apart from the addition of the snake in the painting, and the change of text along the top.

The painting of *Nuda Veritas* was bought by Hermann Bahr, a dramatist and critic. He was a staunch supporter of the Secession from the beginning and acted as an adviser to the editorial board of *Ver Sacrum*. It was Bahr who had urged the establishment of such a journal: 'The disgraceful fact that Austria boasts not a single illustrated art magazine enjoying a wide circulation and tailored to its particular needs has prevented artists from becoming known. This journal should prove of help to them.' Bahr commissioned the architect Joseph Maria Olbrich to build a small house for him, and the panelling in the study was specially designed to accommodate Klimt's painting.

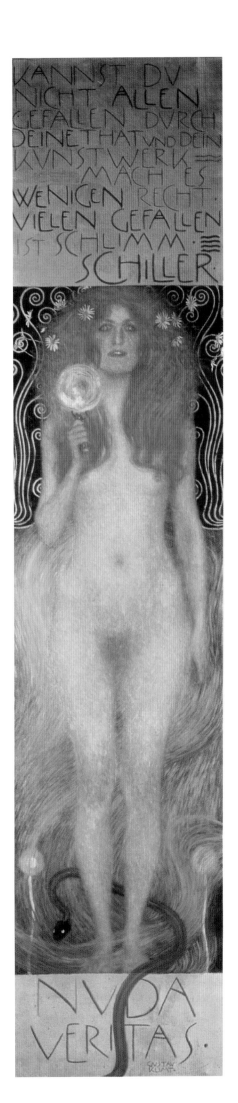

Portrait of Serena Lederer

1899. Oil on canvas, 188 x 85.4 cm. Metropolitan Museum of Art, New York

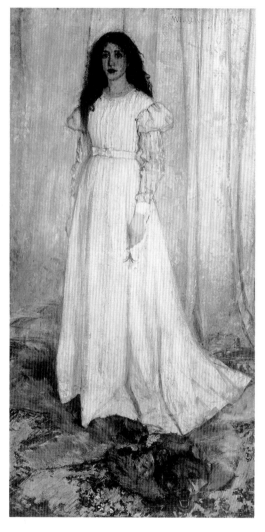

Fig. 21
JAMES MCNEILL
WHISTLER
Symphony in White
No. 1: The White Girl
1862. Oil on canvas,
214.6 x 108 cm. National
Gallery of Art,
Washington, DC

No doubt encouraged by the success of Klimt's *Portrait of Sonja Knips* (Fig. 12), Serena Lederer commissioned a portrait of herself. The painting's narrow format is like that of the central panel of the *Hofburg Actor Josef Lewinsky as Carlos* (Plate 4), although it does not have the wide frame of the earlier work.

The portrait is chiefly remarkable, however, for its similarity to works by Whistler, such as his *Symphony in White No. 1: The White Girl* (Fig. 21). Until he went to London in 1906, Klimt would only have seen Whistler's work in black and white reproductions, yet the two paintings are very close in terms of composition, colouring and technique. Klimt uses white for the subject and background so that the figure is both distinct from her surroundings and dissolves into them. As in Whistler's painting, the darkest elements in Klimt's work are the girl's hair, eyebrows, eyes and mouth – an emphasis that is obviously erotic.

The Lederers amassed quantities of Klimt's work, buying paintings and numerous drawings. They also commissioned a painting of their daughter, Baroness Elisabeth Bachofen-Echt (Fig. 14). At an exhibition of 200 drawings organized shortly after Klimt's death, Serena Lederer arrived demanding how much the entire show cost. She bought the whole lot. The Lederer collection of Klimt's works was ill-fated. When Austria was annexed by Germany in 1938, the entire collection – save the family portraits – was confiscated. Many of the paintings, including the Faculty Paintings (*Philosophy*, Fig. 6, *Medicine*, Fig. 7 and *Jurisprudence*, Fig. 10) and *Schubert at the Piano* (Plate 13), were taken to the Schloss Immendorf, where they perished in a fire in 1945. Serena Lederer had taken drawing lessons under Klimt and her son Erich was taught by Egon Schiele. His patronage later helped Schiele enormously. Erich, who emigrated to Geneva in 1938, eventually managed to retrieve his Klimt and Schiele drawings from the authorities.

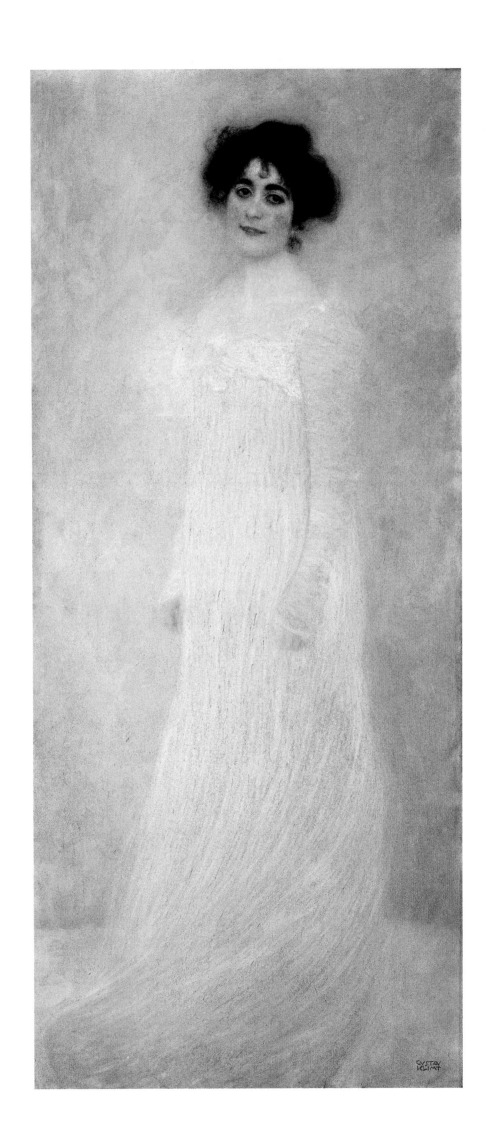

Schubert at the Piano

1899. Oil on canvas, 150 x 200 cm. Destroyed by fire at the Schloss Immendorf in 1945

In 1898, the Greek industrialist Nikolaus Dumba commissioned Hans Makart (1840–84) – a then fashionable painter – Franz Matsch and Gustav Klimt to decorate three rooms in his luxury apartment with paintings and also furniture. This involved quite different considerations from anything Klimt had tackled before. He was to produce two paintings to go in the panelling above the doors for a private client, on a domestic scale.

Klimt was given the music room. A watercolour survives, showing how he envisaged the paintings in relation to the decoration of the rest of the room. While one of the canvases, *Music II* (Fig. 22), is an allegorical work harking back to earlier paintings, the other, *Schubert at the Piano*, is highly innovative. Presumably Dumba requested that Schubert be the subject of the picture; he was certainly popular at the time and he also happened to be Klimt's own favourite composer. What is particularly striking about Klimt's portrayal of the musician is the way in which Klimt has completely abandoned the idea of an accurate historical representation, depicting the onlookers in contemporary dress. The subtle lighting given off by the candle tends to dissolve the elements in the picture. It is not possible to determine the space in which the figures are shown and only Schubert's profile stands out in sharp focus. The woman on the left is Marie Zimmermann, one of Klimt's mistresses, who gave birth to two sons by the artist.

Schubert's era was regarded not as a period of history which might have been exemplary (compare the earlier decorations for the Burgtheater, Plate 1), but as a different version of turn-of-the-century Vienna. Both of Klimt's works for the music room are attempts to say that the past is also the present; that Antiquity as seen in *Music II*, with its distinctly modern-looking female figure, and the Biedermeier era in which Schubert lived, also form part of the present.

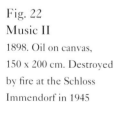

Fig. 22
Music II
1898. Oil on canvas,
150 x 200 cm. Destroyed
by fire at the Schloss
Immendorf in 1945

Portrait of Joseph Pembauer

1890. Oil on canvas, 69 x 55 cm. Tiroler Landesmuseum Ferdinandeum, Innsbruck

Klimt's most extraordinary frame surrounds this near-photographic portrait of the pianist Joseph Pembauer. Its wide, flat surface is decorated with various and apparently unrelated, motifs. At top right stands Apollo, the Greek god of music, playing a lyre – a motif echoed in the background of the actual portrait, in a clear reference to Pembauer's musical career. Moving clockwise around the frame is a decorative Ionic column, a fish, a spatula dangling from a loop of rope, adorned with the initials G S which was the trademark of a well-known café in Munich, two heads, a Delphic tripod like that in the *Hofburg Actor Josef Lewinsky as Carlos* (Plate 4) and some circles and stars.

The very limited colour range – red, black and gold – and the decorative effect of the motifs combine to produce a portrait with an air of opulence and luxury, fitting for a successful male pianist.

15 Judith I

1901. Oil on canvas, 84 x 42 cm. Österreichische Galerie, Vienna

Judith was the biblical heroine who seduced and then decapitated General Holofernes in order to save her home city of Bethulia from destruction by the enemy, the Assyrian army. The subject was quite popular from the Middle Ages onwards, as an example of virtue overcoming vice. However, this work is not a timeless allegory, since Judith is depicted as a Viennese society beauty. The model was Adele Bloch-Bauer and if we compare it with her portrait (Plate 34) it is easy to see the facial similarity. There seem to have been two principal Klimt types. The first was this dark-haired woman of angular build, also seen in *Judith II* (Plate 38). The other favourite was the fleshy, Rubenesque beauty portrayed in *Goldfish* (Plate 16), *Danaë* (Plate 35) and *Leda* (Fig. 33). Judith's sensuality and her orgasmic expression as she holds up the head of Holofernes (reminiscent of the *Ecstasy of St Theresa* by the great Baroque sculptor Gianlorenzo Bernini (1598–1680) in Sta Maria della Vittoria in Rome) shocked Vienna. The Viennese could not bring themselves to see this brazen *femme fatale*, who is clearly taking pleasure in her actions, as the pious Jewish widow who risked her virtue in order to save her city. A far more acceptable solution was to insist that this was a picture of the murderess Salome, despite its being titled on the frame, and for a long time the painting was erroneously known as 'Salome'. The figure of Salome often cropped up in turn-of-the-century Europe, in the works of Oscar Wilde, Aubrey Beardsley (1872–98) and Max Klinger, amongst others.

Judith herself has in a sense been decapitated. The heavy gold choker she wears, fashionable in early twentieth-century Vienna, rather brutally separates her own head from her body. Her clothes half conceal, half reveal her body. The stylized gold band at the bottom of the picture looks as if it might be an ornamental hem to her garment, but then cuts across her abdomen like a flat belt. The painting was bought almost immediately by Klimt's Swiss contemporary, the painter Ferdinand Hodler (1853–1918), whose work Klimt much admired (see *The Choir of the Angels of Paradise*, Plate 22).

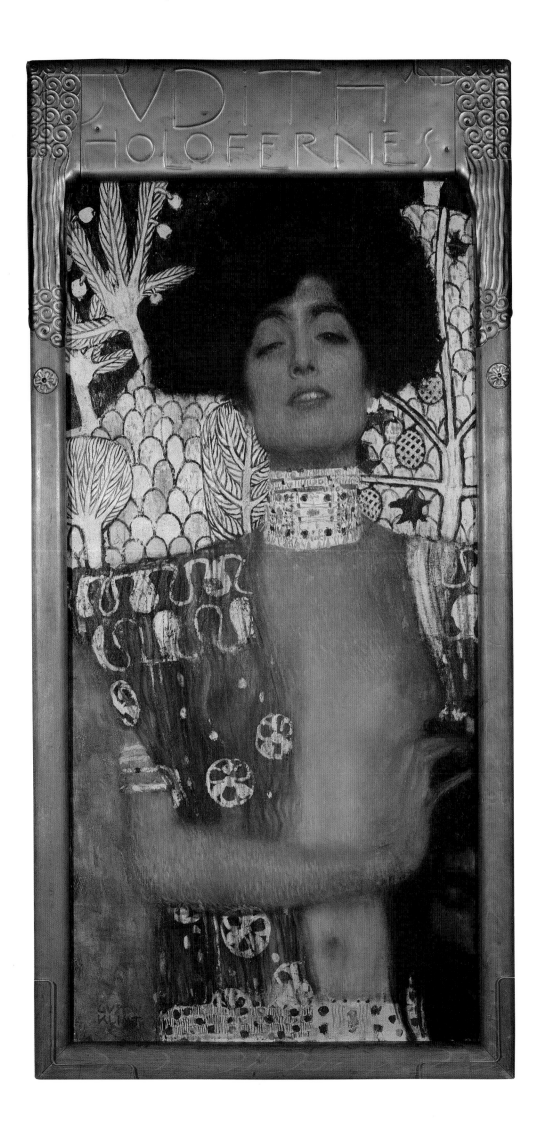

Goldfish

1901–2. Oil on canvas, 150 x 46 cm. Dübi-Müller Foundation, Kunstmuseum, Solothurn

Klimt was so infuriated and exasperated by the hostile reaction to his Faculty Paintings (*Philosophy*, Fig. 6, *Medicine*, Fig. 7 and *Jurisprudence*, Fig. 10) that he painted this mocking riposte. Although he originally called it 'To my Detractors', on the advice of his friends Klimt changed the title to *Goldfish* when he exhibited the work in the 1903 Secession exhibition. Despite the change of title, the Press were up in arms, perhaps unsurprisingly given that the smiling woman is undeniably and provocatively turning her bottom towards the viewer.

The profile of the fish head is very similar to that in *Fish Blood* (Fig. 19). Animals crop up in Klimt's works rather often: there is a snake in *Nuda Veritas* (Plate 11), a swan in *Leda* (Fig. 33), an octopus in *Jurisprudence* (Fig. 10) and *Hope I* (Plate 24) and an ape in *The Forces of Evil* (Plate 20), as well as numerous small birds and butterflies ornamenting many other works. Without doubt, these birds and beasts are not included at random – or Klimt would perhaps have painted some of his beloved cats – but to symbolize character and ideas.

*c*1901. Oil on canvas, 100 x 100 cm. Private collection

Although Klimt's *Island in Lake Atter* and Monet's view of Charing Cross Bridge (Fig. 23) both depict a large area of water, the artists have quite different interests. Monet is concerned with the physical appearance of the River Thames and the bridge in overcast weather conditions; Klimt, on the other hand, focuses on the actual water of the lake.

The high horizon means that the sense of perspective, of moving into the distance, has almost disappeared and so too has the impression of gravity that an expanse of sky would give. The long reflection of the island in the upper right-hand part of the canvas tells us that it projects much further out of the water, beyond the section of it that we see within the frame of the canvas, yet even the reflection is only a fragment of the real size.

Some critics have interpreted this partial vision as a pessimistic view of life, suggesting that logic is unable to provide us with a complete understanding of the world. In 1911, in his book *Towards the Spiritual in Art*, the painter Wassily Kandinsky (1866–1944) wrote about pictures that expressed psychological states disguised in natural forms; he called these 'mood' paintings. Kandinsky suggested that by harmonizing with the viewer's own mood, works such as Klimt's *Island in Lake Atter* can deepen and transfigure one's state of mind.

Fig. 23
CLAUDE MONET
Charing Cross Bridge
(Overcast Day)
1900. Oil on canvas,
60.6 x 91.5 cm. Museum of
Fine Arts, Boston, MA

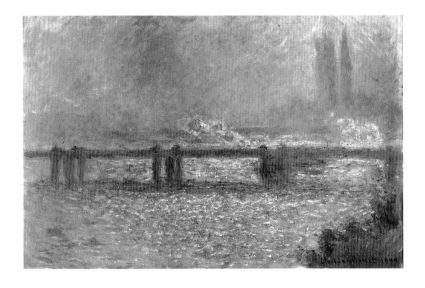

18 Beech Forest I

*c*1902. Oil on canvas, 100 x 100 cm. Gemäldegalerie Neue Meister, Dresden

Klimt seems to have felt equally tranquil in the middle of forests as gazing at expanses of water (see *Island in Lake Atter*, Plate 17). Although the trunks are cut off by the top of the canvas (as in *After the Rain*, Fig. 18), the composition is not claustrophobic. Rather, the trees reach up to the sky like columns in a cathedral created by nature. The central European countries had a long tradition of allegorical paintings of the forest. Albrecht Altdorfer (*c*1480–1538) painted the first pure landscapes, with towering pine trees reaching up out of the picture frame, dwarfing any sense of human scale. The rich heritage of folklore based around the forest, including Grimm's fairy tales, may also have struck a chord with Klimt, as they did, for example, with the Bohemian composer Janácek Leos.

Rather than dwell on the mysterious, dark nature of the forest, Klimt has chosen an apparently autumnal scene, where the colours of the leaves naturally tend towards the golden tones he favoured. The tiny dabs of paint achieve a shimmering effect of light, far from the reality of dank and gloom, while the patterning of the trunks across the width of the canvas hints at a musical rhythm. In other paintings of the forest, Klimt experimented with different types of tree, as in *Birch Wood* of 1903 (Österreichische Galerie, Vienna), in which he has paid close attention to the pattern of the bark.

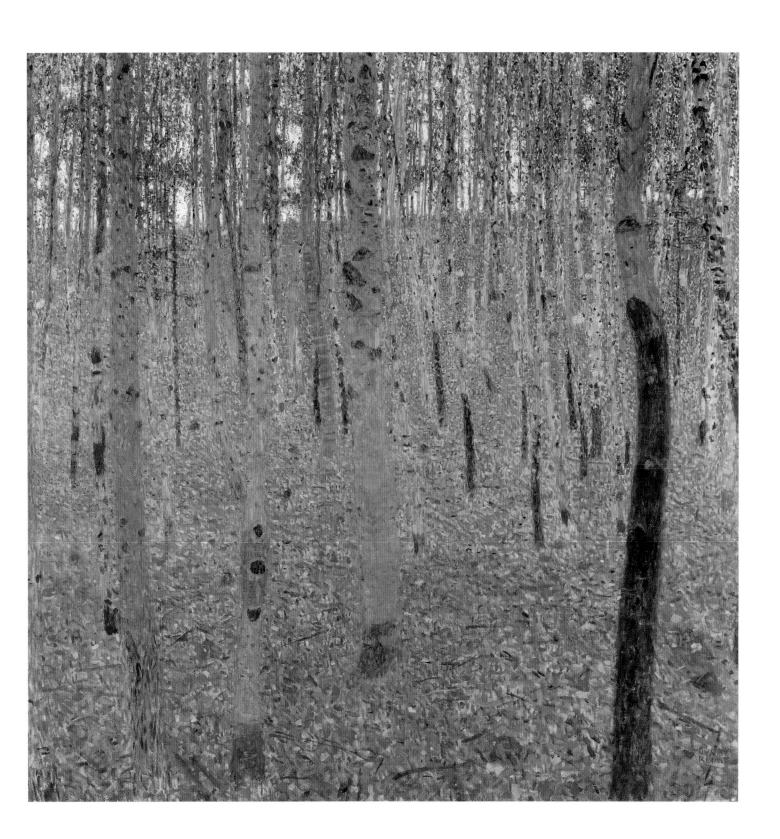

The Longing for Happiness (detail of the Beethoven Frieze)

1902. Casein paint on plaster, h2.2 m. Österreichische Galerie, Vienna

Fig. 24
Life is a Struggle
1903. Oil on canvas,
100 x 100 cm. Private
collection

The fourteenth Secession exhibition, held in 1902, was based around Max Klinger's statue of Beethoven, which had been 17 years in the making. Klinger had been fascinated by news from the Acropolis in Athens that archaeologists had dug up remnants of Antique statues made of coloured stone. This was no doubt the inspiration for his use of a variety of materials in his sculpture of Beethoven: marble, ivory, onyx, alabaster and bronze. All the participating artists contributed work to do with Beethoven, in a show which was to provide a framework for Klinger's statue and to honour Beethoven. After the rediscovery of his work by Franz Liszt and Richard Wagner, the composer was regarded as one of the greatest ever to have lived. Gustav Mahler, who was married to the stepdaughter of one of the Secessionists, agreed to arrange a theme from the Ninth Symphony and perform it at the opening of the exhibition.

Klimt's contribution came in the form of a frieze running round three sides of a room (see Fig. 25). As might be expected, the reaction in the Press was largely negative, with critics condemning the 'obscenity' and 'ugliness' of the figures. They were also somewhat puzzled as to the work's connection with Beethoven. The exhibition's catalogue goes some way to interpret it: 'The longing for happiness. The suffering of weak mankind. Their entreaties to the armoured man to take up their fight for happiness.' Klimt's visual reference for the knight was a ceremonial suit of armour in the Kunsthistorisches Museum in Vienna. The knight has been variously interpreted as a portrait of Mahler, champion of Beethoven's music, as Klimt himself and as an allegorical representation of the creative artist struggling against hostile opinion. The painting *Life is a Struggle* (Fig. 24), also known as 'The Golden Knight', which bears many similarities to this one, is usually thought to represent Klimt's struggle against the authorities, lending credence to the latter interpretation.

The Forces of Evil
(detail of the Beethoven Frieze)

1902. Casein paint on plaster, h2.2 m. Österreichische Galerie, Vienna

The catalogue entry for this painting reads: 'The forces of evil. The giant Typhoeus, against whom even the gods could not prevail; his daughters, the three gorgons. Disease, madness, death. Debauchery and unchastity, excess, nagging grief. The longings and desires of mankind fly overhead.' Facing the knight on the opposite wall was his intended salvation, Poetry, but before he could reach this he had to pass through the forces of evil. The giant Typhoeus is represented by a grimacing ape, while the other vices are personified by *femme fatale* figures (not shown in this detail). The figure of Excess is based on an 1897 illustration by Aubrey Beardsley for the cover of *Ali Baba and the Forty Thieves*.

The photograph of the room in which Klimt's Beethoven frieze was installed (Fig. 25) shows the layout quite clearly. On the left-hand side, at too much of an angle to be distinguishable, is *The Longing for Happiness* section (Plate 19). In the centre, above the decorative relief-work around the door, specially designed by Josef Hoffmann, is *The Forces of Evil*. Finally, on the right-hand side, is the figure of *Poetry* (Plate 21) and *The Choir of the Angels of Paradise* (Plate 22). Through the gap in the wall is Klinger's statue of Beethoven.

Fig. 25
The room at the fourteenth Secession exhibition in which Klimt's Beethoven Frieze was displayed
1902. Photograph.
Graphische Sammlung Albertina, Vienna

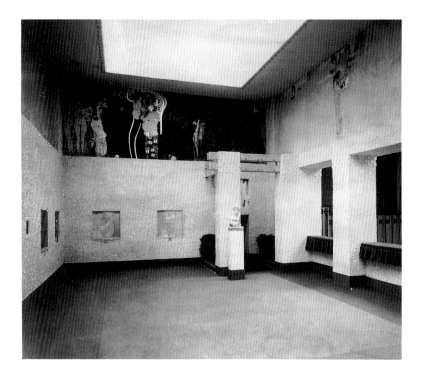

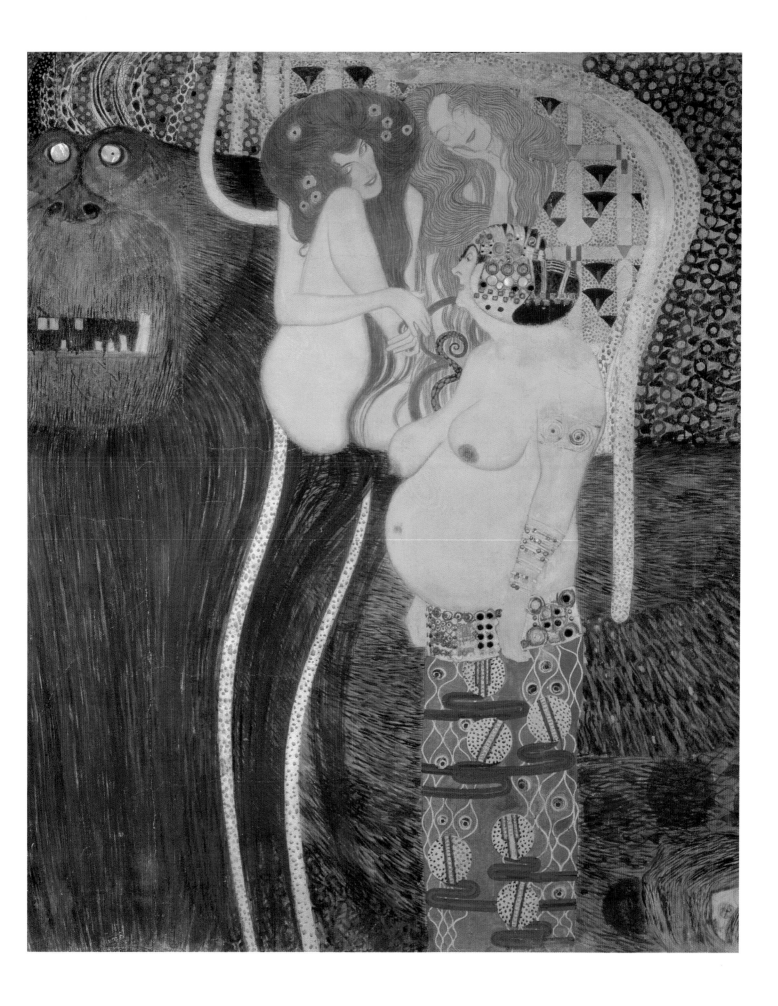

Poetry
(detail of the Beethoven Frieze)

1902. Casein paint on plaster, h2.2 m. Österreichische Galerie, Vienna

The catalogue describes the right-hand wall as follows: 'The longing for happiness finds fulfilment in poetry. The arts guide us to the ideal realm where alone we can find joy, pure happiness and pure love. Choir of the angels of paradise. "Joy, heaven-descended flame. This kiss of the whole world".' This last quote comes from Schiller's text from Beethoven's Ninth Symphony, Klimt's only direct reference to the subject of the exhibition.

The first section of the right-hand wall, then, contains the figure of Poetry. It is a clear echo of Klimt's earlier painting *Music I* (Plate 5), with the bowed figure playing the lyre. The lyre is traditionally the attribute of Poetry, and also of Erato, the Muse of lyric and love poetry.

The walls were left bare on either side of this figure. This was deliberate, as the statue of Beethoven, the centrepiece of the exhibition, was visible through a gap in the wall. Klimt and the exhibition's designers had not wanted to detract from the importance of Klinger's masterpiece. The figure of Poetry is not entirely separated from the rest of the frieze, however: along the top 'The longings and desires of mankind fly overhead'. These elongated linear figures, rather like those in *Water Snakes I* (Plates 26), are highlighted in gold and link the diverse elements in the frieze.

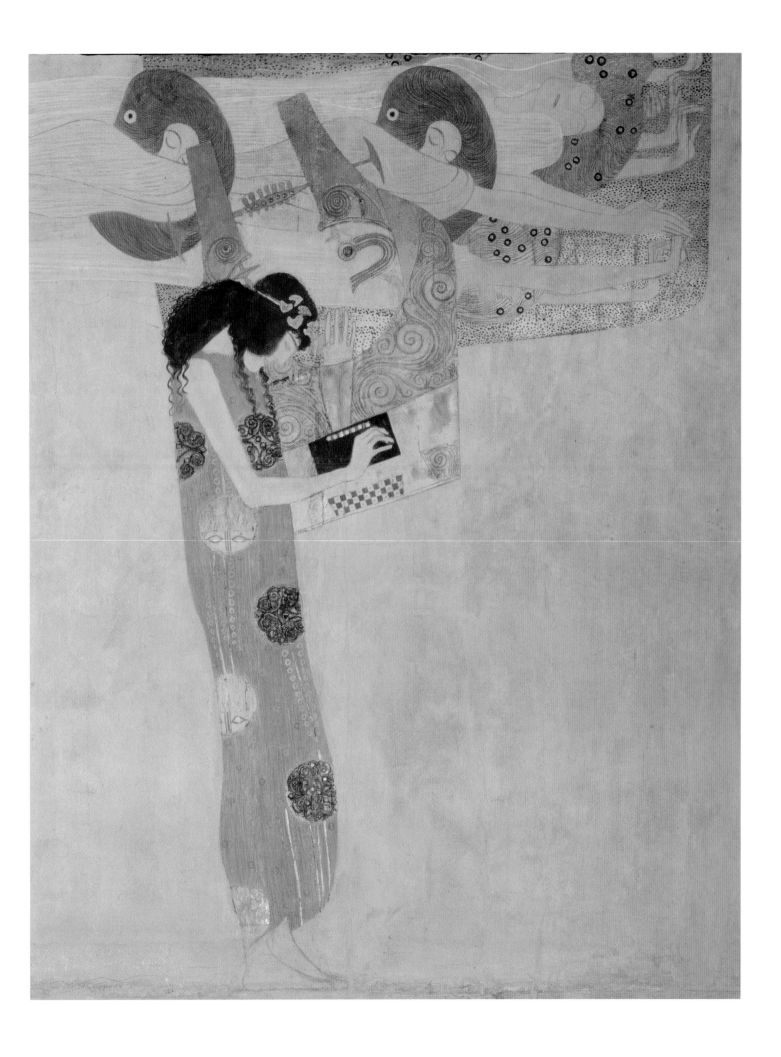

The Choir of the Angels of Paradise
(detail of the Beethoven Frieze)

1902. Casein paint on plaster, h2.2 m. Österreichische Galerie, Vienna

The Choir of the Angels of Paradise owes much to a painting by the Swiss artist, Ferdinand Hodler. In 1900, Hodler had been made a member of the Secession and the following year he sent to their exhibition two works, including *The Chosen One* (Kunstmuseum, Bern). It shows a young boy kneeling before a semicircle of angels who float above the ground. Klimt's rows of angels are closer together than Hodler's, but their feet floating above the ground and their gestures are clearly derived from Hodler's work. Hodler did not mind the borrowing at all; he spoke and wrote warmly of Klimt and even bought *Judith I* (Plate 15).

At the far right of the frieze is the kissing couple who, via the guidance of the arts, have triumphed over adversity and achieved perfect love. The figures reappear in two later works by Klimt: *Fulfilment* (Plate 31), part of the Stoclet Frieze, and *The Kiss* (Plate 36).

A copy of *The Chosen One* was bought by the industrialist and collector, Carl Reininghaus, who also bought the Beethoven Frieze. The frieze was only intended to be a temporary work and was due to be destroyed at the end of the exhibition. However, Reininghaus decided to buy the work, thus saving it for posterity. In 1917 Egon Schiele negotiated its sale to the Lederer family, who in turn sold it to the Austrian State in 1973. After years of restoration work, it has now been reinstalled in the basement of the Secessionist building, in an exact replica of the room for which it was originally painted.

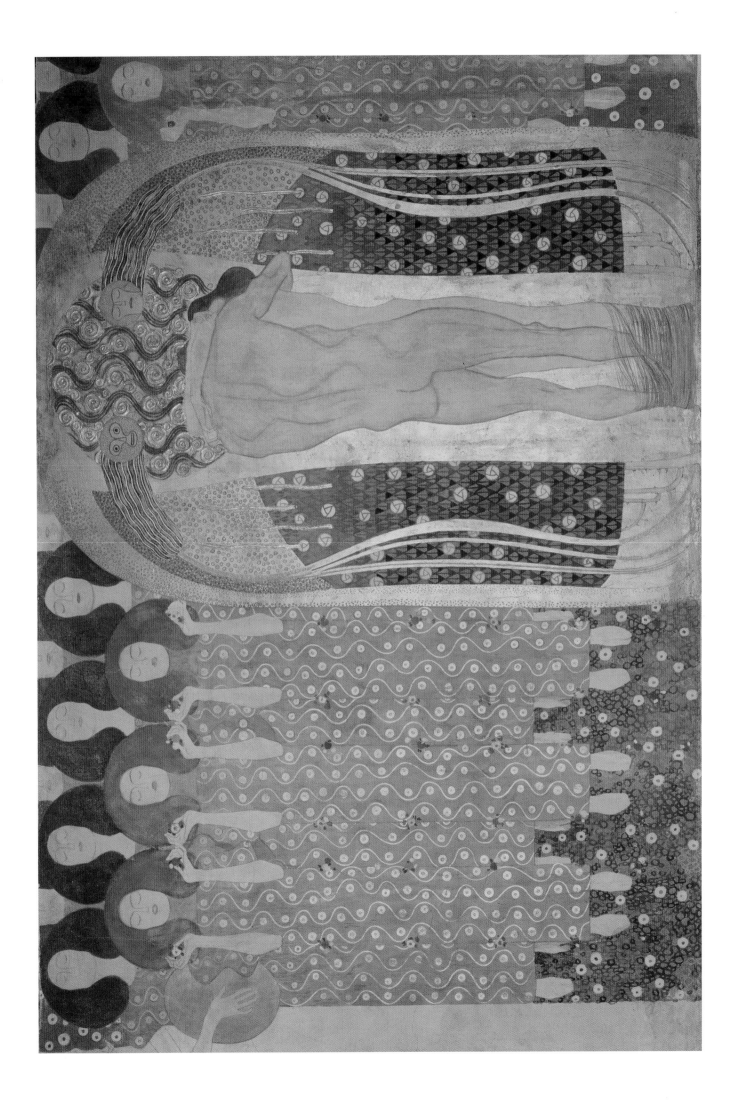

Portrait of Emilie Flöge

1902. Oil on canvas, 181 x 84 cm. Historisches Museum der Stadt Wien, Vienna

Fig. 26
MADAME D'ORA-
BENDA
Emilie Flöge
1909. Photograph.
Österreichische
Nationalbibliothek,
Vienna

Neither Emilie nor her mother liked this portrait and it was sold to the Historisches Museum der Stadt Wien, Vienna in 1908. The dress is quite different from the ones Emilie designed and made, and her mother was horrified by its modernity. Klimt promised to paint a second one, but never did. Oddly enough, no drawings of Emilie Flöge survive, but it seems inconceivable that Klimt did not draw her. What do remain are several charming photographs of Emilie, dressed in clothes from the Vienna Workshop (Fig. 26), sometimes with Klimt at Salzkammergat and a few taken of her in her salon.

In the bottom right of the portrait are two small squares. The top one contains Klimt's signature and the date, which has been spaced out to mark the two lower corners of the square. Klimt was to repeat this arrangement in his *Portrait of Adele Bloch-Bauer I* (Plate 34). Below it is a second square, in which Klimt's interlocked initials appear. The catalogue of the fourteenth Secession exhibition of 1902 has a double-page spread in which all the participating artists constructed a design from their initials within the confines of a square. Other doodles survive, showing Klimt experimenting with different ways of interlinking the 'G' and the 'K' of his name.

These two squares, particularly the gold one, look rather like tiny plaques screwed onto the picture surface. However, Klimt has softened the contrast between the painterly manner with which he has depicted Emilie herself, and the artificiality of the 'labels' by using the same colours in each. Emilie's dress is decorated with geometric motifs – squares, circles, ovals and spirals – many of which have been picked out in gold. Similarly, the initials and the background in the bottom square are composed of colours seen in Emilie's dress and in the umbrella, or hat-like shape behind her head.

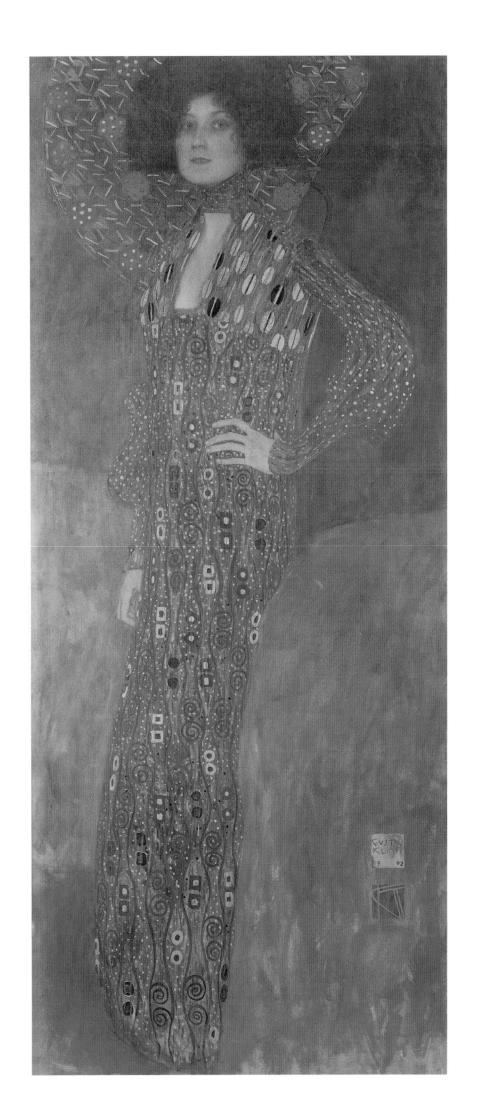

1903. Oil on canvas, 189 x 67 cm. National Gallery of Canada, Ottawa

Fig. 27
Hope II
1907–8. Oil on canvas,
189 x 67 cm. Museum of
Modern Art, New York

One of Klimt's models, Herma, had, according to the artist, an 'arse' more beautiful than many of his other models' faces. The story goes that he was understandably upset when she failed to turn up one day and so he sent someone to look for her. Word came back that Herma was pregnant and therefore could not pose for him. Klimt insisted that she model nonetheless, and despite Herma's own misgivings she eventually agreed, thus enabling the artist to paint *Hope I* (if one believes this apocryphal tale).

Hope I was bought by Fritz Waerndorfer, the financier behind the Vienna Workshop who unfortunately went bankrupt in 1914. The painting was kept in a special cabinet designed by Koloman Moser and was only shown to select friends. When it was proposed that the work be included in the 1901 exhibition in the Secession building, it was rejected by the censors on the grounds of obscenity. Waerndorfer was also proud to have commissioned Charles Rennie Mackintosh (1868–1928) and his wife, Margaret Macdonald (1865–1933), to design his music room. Klimt, like the rest of the Secession, was undoubtedly impressed by the harmony of the room's paintings and furnishings. Unfortunately, only a drawing of it by Margaret Macdonald remains; the room's furnishings were dispersed after the sale of the house in 1914 when Waerndorfer was forced by his exasperated family to go to the United States.

A later version of the same subject, *Hope II* (Fig. 27), clothed and therefore more acceptable, was painted at the same time as *The Kiss* (Plate 36). The two are closely related in terms of composition and colouring.

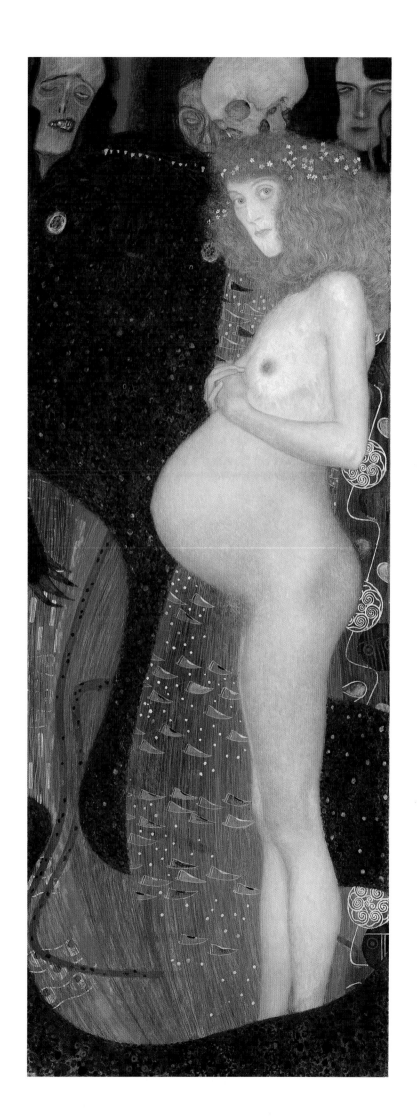

Portrait of Hermine Gallia

1903–4. Oil on canvas, 170 x 96 cm. National Gallery, London

This portrait was shown at the 1903 Secession exhibition but only completed the following year. Like several of Klimt's other portraits of women (see those of Serena Lederer, Plate 12 and Margaret Stonborough-Wittgenstein, Plate 28), Hermine, one of the daughters of Karl Wittgenstein, wears a white dress, similar to those created by Emilie Flöge. This is the first commissioned portrait in which Klimt uses abstract, geometric designs within the dress and the background. Diamonds composed of hexagons and triangles mark out the floor, while the train of Hermine's dress shows a chequerboard effect. His *Portrait of Emilie Flöge* (Plate 23), painted the previous year, included this kind of ornament but that was a private work.

Hermine Gallia's pose is quite different from that of Klimt's other female sitters, in that rather than holding herself upright, in an aloof, if not distant pose, she leans forward slightly towards the viewer. Her clasped hands and the slight upwards tilt of her head make her look as if she is about to ask a question. Perhaps Klimt simply knew her better than some of his other sitters. Hermine certainly wrote about the circumstances surrounding the various commissions the Wittgensteins gave Klimt in her memoirs, *Family Reminiscences*.

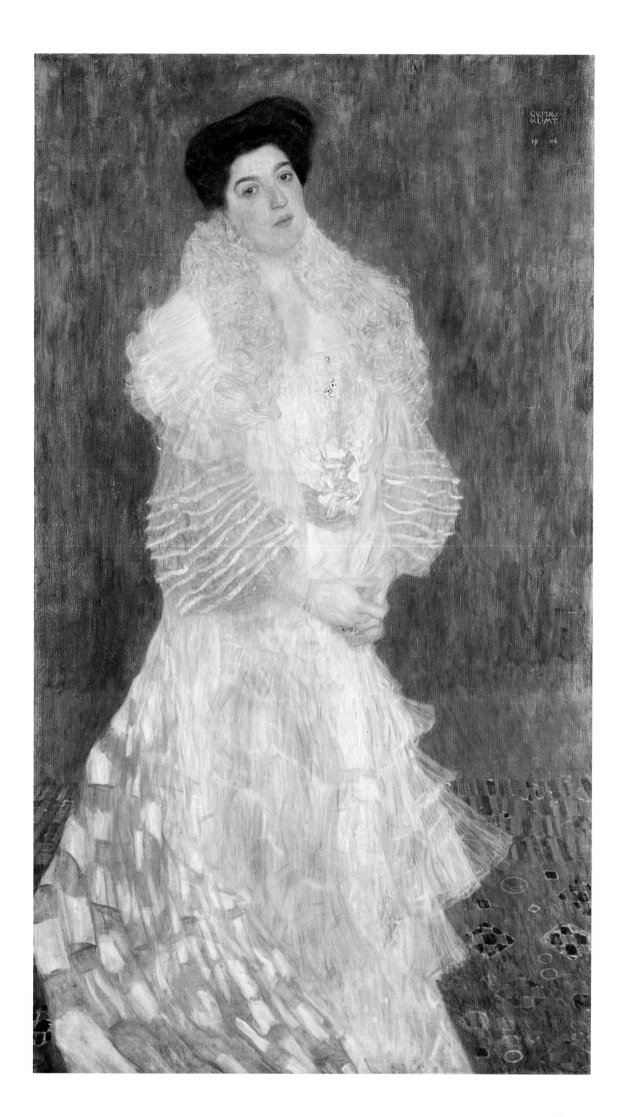

1904–7. Watercolour and gold paint on parchment, 50 x 20 cm. Österreichische Galerie, Vienna

Klimt returned to the theme of 'sensual women in water', seen in earlier works such as *Flowing Water* (Plate 9), *Mermaids* (Plate 10) and *Goldfish* (Plate 16), in two works known as *Water Snakes I* and *Water Snakes II* (Private collection). Unlike the others, *Water Snakes I* is not an oil painting, and its pale, unusual colouring is in part dictated by the medium used. It does not differ much from the preliminary drawings that Klimt used for reference, apart from the addition of the gold paint, and the green and gold-leaf threads entangled around the women's bodies.

The unambiguously lesbian embrace of his models would perhaps have been unacceptable had it been presented as a straight portrait. However, by renaming the work and giving it an allegorical theme and by adding the fish-like serpent behind the bodies and adorning every surface with gold and pattern, Klimt was able to show the painting to Vienna without fear of censorship. In a later painting, *Women Friends*, dating from 1916 to 1917 (destroyed in 1945), Klimt portrayed lesbianism much more openly. A naked young girl with parted lips rests her head against her lover, who holds a wrap, partly covering their nudity.

Although Klimt did not meet Egon Schiele until 1909, Schiele's work on the same subject, *Water Sprites I* (Fig. 28) is strikingly similar to Klimt's two paintings, both dating from 1904–7. The 'Longings and Desires of Mankind' in Klimt's Beethoven Frieze (see *The Forces of Evil*, Plate 20) is very close in style to Schiele's slightly later work; and although Schiele would only have been 12 years old at the time of the exhibition in 1902, the image would have been available to him in reproduction.

Fig. 28
EGON SCHIELE
Water Sprites I
1907. Gouache, coloured crayon, silver and gold paint on paper, 24 x 48 cm.
Private collection

The Three Ages of Woman

1905. Oil on canvas, 178 x 198 cm. Galleria Nazionale d'Arte Moderna, Rome

Like the Faculty Paintings (*Philosophy*, Fig. 6, *Medicine*, Fig. 7 and *Jurisprudence*, Fig. 10), this is an example of Klimt's symbolic and allegorical works. He continued to paint such images right until his death in 1918 (see *The Bride*, Plate 48). The painting shows a little girl in the protecting arms of a young woman, while beside them an old woman stands with bowed head. Like the skull in *Hope II* (Fig. 27), the aged crone is symbolic of the passage of time.

The figure of the old woman is based on a sculpture by Auguste Rodin (1840–1917), called *The Old Courtesan* (Musée Rodin, Paris) also known as 'She who was once the Helmet-Maker's Beautiful Wife', which was exhibited in Vienna in 1901 as part of the ninth Secession exhibition. The show, devoted to the works of Rodin, the painter Giovanni Segantini (1858–99) and Klinger, had a lasting effect on Klimt, who was delighted when he was able to meet Rodin the following year during the sculptor's visit to Vienna. Rodin saw and praised the Beethoven Frieze (Plates 19–22); the admiration was mutual.

The black background is unusual in Klimt's work up to this date. Another painting, called *Death and Life* (Private collection), which was begun three years later in 1908, started out with a gold background. However Klimt was not happy with it and substituted a blue-black background in 1911. Most of his later symbolic works share these dark grounds, in sharp contrast to the continued brightly coloured decoration of the figures themselves.

Bought in 1912 by the Galleria Nazionale d'Arte Moderna in Rome, *The Three Ages of Women* had won the gold medal in the 1911 International Exhibition, also held in Rome.

Portrait of Margaret Stonborough-Wittgenstein

1905. Oil on canvas, 180 x 90 cm. Neue Pinakothek, Munich

Fig. 29
JAMES TISSOT
A Portrait
(Miss Lloyd)
1876. Oil on canvas,
91.4 x 50.8 cm. Tate
Gallery, London

Margaret Stonborough-Wittgenstein was the daughter of the wealthy iron and mining magnate, Karl Wittgenstein. He was already one of Klimt's patrons, having bought *Life is a Struggle* (Fig. 24). He subsequently bought *Water Snakes I* (Plate 26) and *The Sunflower* (Fig. 30), among others. Karl Wittgenstein's family was very well connected, if a little extraordinary: the three eldest children committed suicide, while the remainder went on to become famous. One of the surviving siblings was the philosopher, Ludwig Wittgenstein, who built a house for Margaret; another, Paul, a pianist, lost his right arm in the First World War and inspired Maurice Ravel and Johann Strauss to write pieces for the left hand. Margaret herself was a society lady, rather like Miss Lloyd (Fig. 29) in the portrait by James Tissot (1836–1902), but she also played an important role in the Viennese art world, serving as president of the Vienna Arts and Crafts Society in the 1920s.

This portrait was commissioned by Karl on the occasion of his daughter's marriage. The formality of her pose is echoed by the architectural elements – inspired by Josef Hoffmann – in the background. Like the *Portrait of Serena Lederer* (Plate 12) and the *Portrait of Hermine Gallia* (Plate 25), the subject wears a white dress. Klimt clearly enjoyed using white on white to indicate the patterns and embroidery on the dress by the simplest of means.

The dark horizontal band at knee height and the geometric shapes at the top of the picture are later additions; Klimt was not satisfied with the original composition. However, despite these changes, Margaret did not like the portrait and banished it to the attic of her summer house.

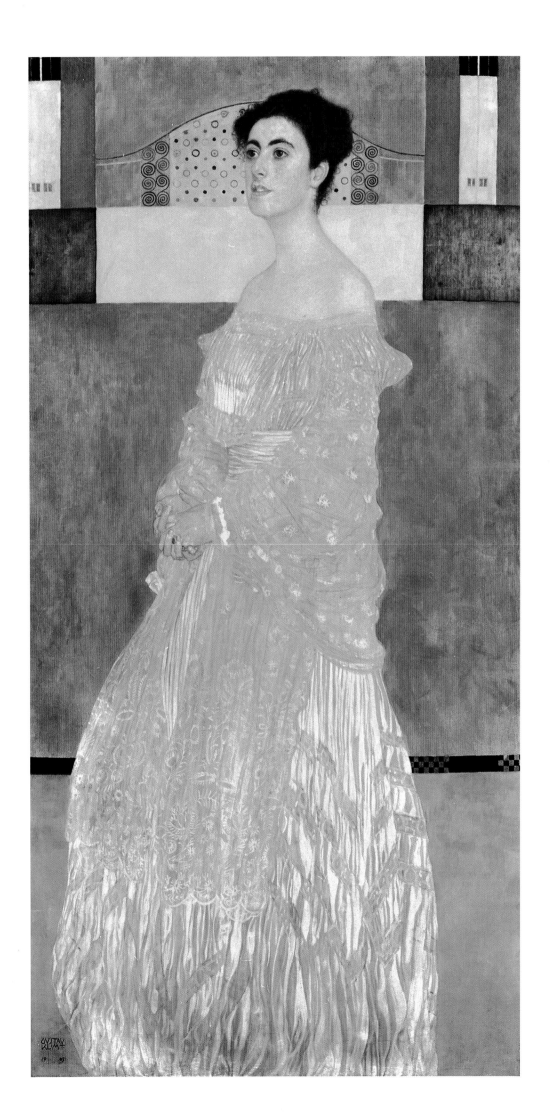

1905–6. Oil on canvas, 110 x 110 cm. Österreichische Galerie, Vienna

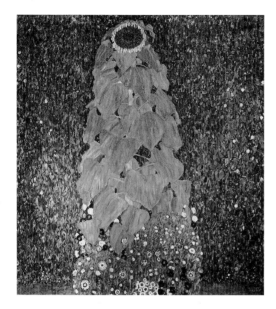

Fig. 30
The Sunflower
1906–7. Oil on canvas,
110 x 110 cm. Private
collection

Farm Garden with Sunflowers was painted in the garden of an inn in which Klimt stayed while visiting Litzlberg on Lake Atter. In the mass of brightly coloured flowers and leaves, it is possible to pick out distinct blooms, such as the pink flowers on the bottom right, punctuating and quietly organizing the picture surface.

The Sunflower (Fig. 30) is unusual in Klimt's paintings of trees and flowers in that there seems to be a certain anthropomorphic element. One immediately thinks of Van Gogh's sunflowers, which were almost self-portraits. However, Klimt's flowers are still *in situ*, growing in the garden, while Van Gogh's have been picked and arranged in a vase. Van Gogh's sunflower paintings are still lifes, whereas Klimt's images are details of the landscape. The shape of the flower and leaves in *The Sunflower* is remarkably like the form of the lovers in *The Kiss* (Plate 36). The two works were exhibited for the first time in 1908 at the Art Show Vienna.

Unlike the earlier landscapes from around 1898 to 1902, these two paintings of sunflowers are no longer concerned with mood; rather, Klimt is fascinated in a more objective way by the organic life that simply exists, independent of human intervention. The geometrical composition of his paintings is no longer merely used for decorative effect, but to reinforce the artist's detached observation of the scene while delighting in the opulence and abundance of nature.

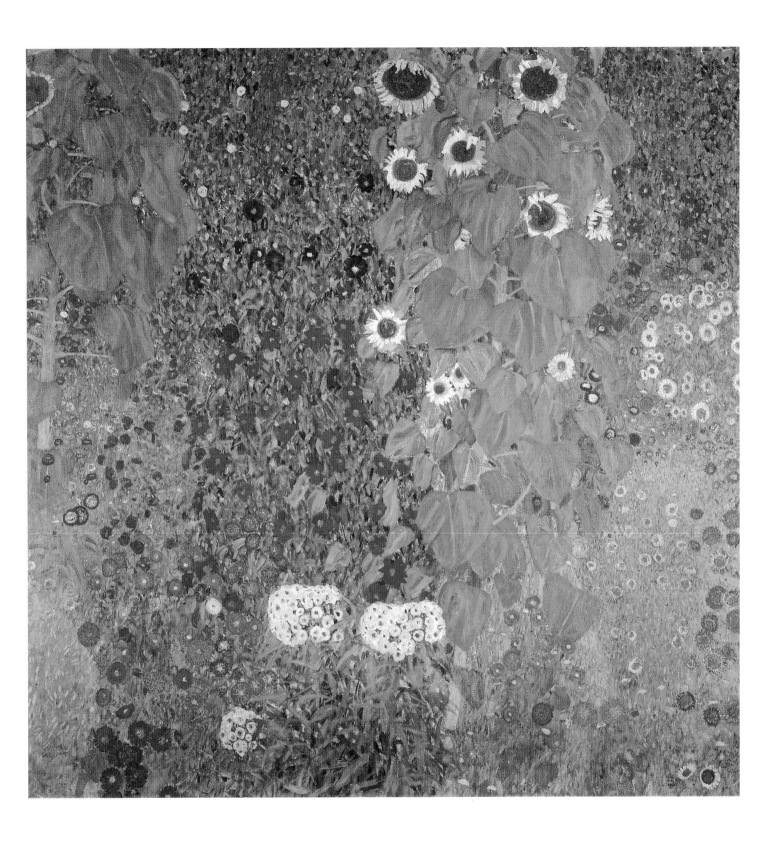

30 Expectation
(cartoon for a section of the Stoclet Frieze)

1905–9. Tempera, watercolour, gold paint, silver bronze, chalk, pencil and white paint on paper, 193 x 115 cm. Österreichisches Museum für Angewandte Kunst, Vienna

The Palais Stoclet in Brussels was built by Josef Hoffmann between 1905 and 1911. Its owner, the banker Adolphe Stoclet, had encountered Hoffmann and his work during the years he and his wife lived in Vienna. The building is a triumphant example of the ideals of the Vienna Workshop. Exterior and interior, furniture and decoration are fused in a way that had not been possible elsewhere. Hoffmann used the word 'Gesamtkunstwerk', which translates as 'the total work of art', or 'artistic synthesis', to describe his goal, and Klimt's frieze for the dining room admirably illustrates the point.

He produced a life-sized working drawing on tracing paper which was attached to the marble plates. The pencil marks were then transferred onto the stone. Several craftsmen – gilders, marble workers and enamellers – collaborated on the project, assembling the frieze in the mosaic workshop of Leopold Forstner, following Klimt's detailed instructions about colours and materials. Like the Beethoven Frieze (see Fig. 25), the Stoclet Frieze runs around three sides of the room (see Fig. 11). A tree of life, with ornamental spiralling branches, decorates each of the opposite walls which are identical but for the figures on either side: *Expectation*, originally called 'The Dancer', and *Fulfilment* (Plate 31), originally called 'Embrace'. On the end wall was a third mosaic panel, apparently abstract, which has recently been identified as a knight. It is a much freer and more imaginative image than the knight of the Beethoven Frieze (see *The Longing for Happiness*, Plate 19) but probably carries the same symbolic associations. The figure of *Expectation* is clearly inspired by Egyptian art, both in terms of the woman's profile and the position of her arms and hands. The figure also owes something to a dance popular at the time.

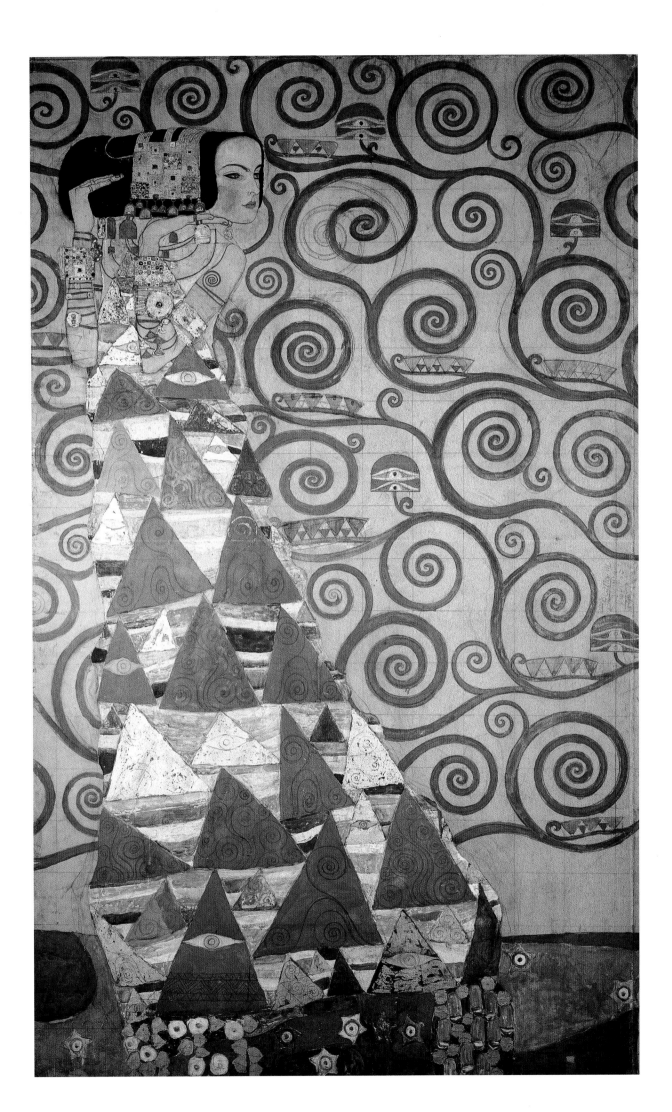

Fulfilment
(cartoon for a section of the Stoclet Frieze)

1905–9. Tempera, watercolour, gold paint, silver bronze, chalk, pencil and white paint
on paper, 194 x 121 cm. Österreichisches Museum für Angewandte Kunst, Vienna

Fulfilment reworks the theme from the last section of the Beethoven
Frieze, *The Choir of the Angels of Paradise* (Plate 22), and predates *The
Kiss* (Plate 36). The three couples are very similar, with the man's
back turned towards the viewer, shielding his lover's body while
exposing her rapt face. In all three versions the man's head is bent
over so that it is on a level with hers; in *The Kiss* this is achieved by
having the woman kneel, while in the other paintings Klimt simply
makes the man taller. All three works place the couple against a
broadly gold background, whether flat, patterned or speckled, which
has the effect of setting them apart from ordinary, earthly love.

On the man's robe is a square with further squares – albeit some
distorted – inside it, picked out in black, white, shades of grey and
gold. Klimt often seems to have contrasted square or rectangular
shapes with circles and spirals to illustrate the difference between
masculinity and femininity. The overlapping of the two shapes seems
to suggest a sort of physical and spiritual union achieved by the
couple, as in *The Kiss*.

Koloman Moser and Josef Hoffmann made extensive use of the
square in their furniture for the Palais Stoclet, producing a chequer-
board floor for the dining room and employing rows of alternating
black and white squares around the backs of the dining chairs. Klimt
used this same pattern in his 1905 *Portrait of Margaret Stonborough-
Wittgenstein* (Plate 28).

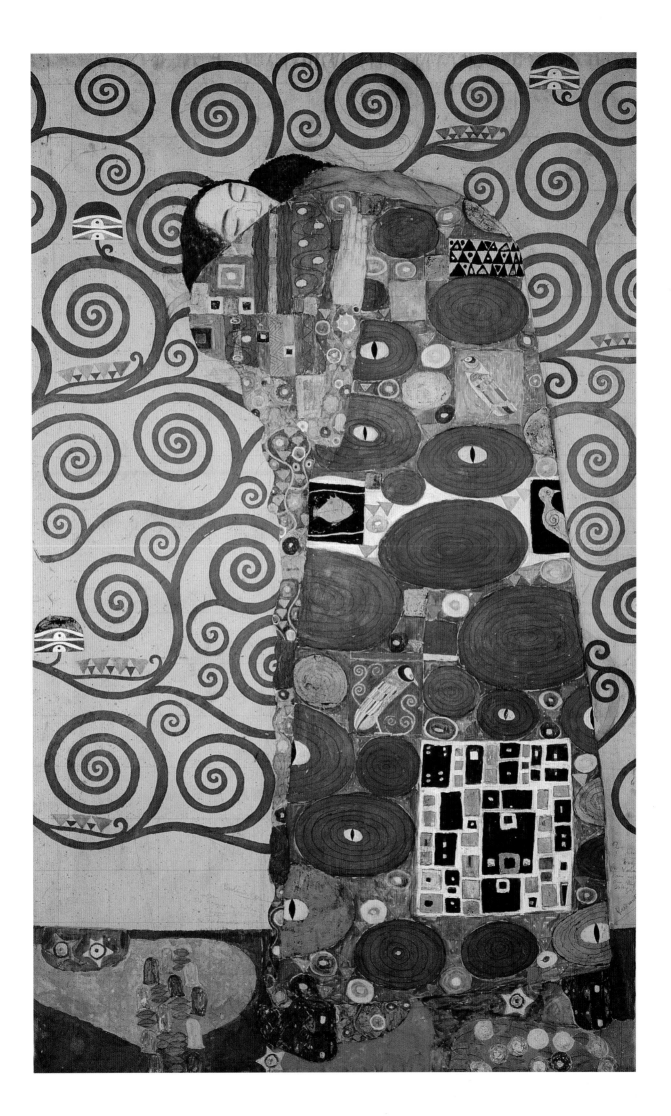

Tree of Life
(cartoon for a section of the Stoclet Frieze)

1905–9. Tempera, watercolour, gold paint, silver bronze, chalk, pencil and white paint on paper, 194 x 118 cm. Österreichisches Museum für Angewandte Kunst, Vienna

On either side of the dining room, at the opposite end of the room from the figures of *Expectation* and *Fulfilment*, is this shrub which forms part of the *Tree of Life*. The pattern of its leaves is not unlike the designs in *Water Snakes I* (Plate 26) and the trails of golden threads are similar to those at the bottom of *The Kiss* (Plate 36). The art critic Ludwig Hevesi wrote about Klimt's work:

> Ornament to Klimt is a metaphor of matter itself in a state of perpetual mutation, ceaselessly evolving, turning, spiralling, undulating, twisting, a violent whirlwind that assumes all shapes, zigzags of lightning and flickering tongues of serpents, tangles of vines, links of chains, flowing veils, fragile threads.

In the spiralling branches of the *Tree of Life* are reasonably lifelike birds and butterflies. This tree design is interesting in that it is the only surviving example of a landscape in which Klimt uses gold. There was one other painting that did so, *The Golden Apple Tree*, made in 1903, which was destroyed in 1945 in the fire at the Schloss Immendorf along with so many other key works.

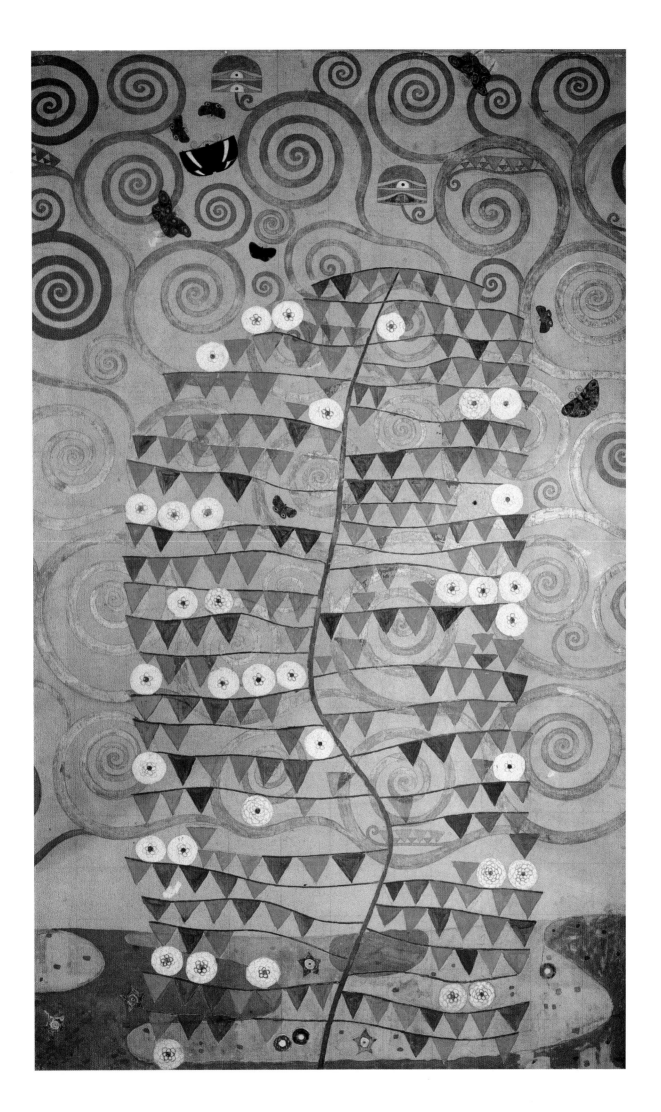

Portrait of Fritza Riedler

1906. Oil on canvas, 153 x 133 cm, Österreichische Galerie, Vienna

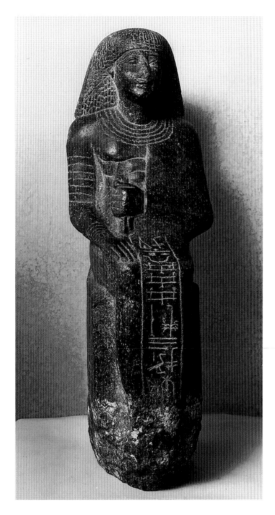

Fig. 31
Sitting Statue of
Merimose
*c*1380 BC. Granodiorite,
h69 cm. Kunsthistorisches
Museum, Vienna

This painting is similar to the *Portrait of Margaret Stonborough-Wittgenstein* (Plate 28). The treatment of the women's white dresses is very close, as are the geometrical blocks of colour in the background. Fritza Riedler, however, is seated, and here Klimt has let his imagination take over. The armchair in which she sits – perfectly realistic in the preparatory drawings – has virtually disappeared, becoming a two-dimensional outline filled in with gold and silver eye-shaped motifs. The gold and silver are picked up by the small squares dotted across the background wall.

As in the portrait of Margaret Stonborough-Wittgenstein, Klimt has placed a roughly semicircular shape behind Frieda's head. This serves to frame and draw attention to her face, in the same way that Tissot places Miss Lloyd (Fig. 29) in a doorway. However, the mosaic-like semicircular decoration in the *Portrait of Fritza Riedler* is more complicated than in the earlier work, and would appear to derive from two sources: Velázquez and Egyptian art. There is a *Portrait of Queen Mariana of Austria*, formerly ascribed to Diego Velázquez (1599–1660), in the collection of the Kunsthistorisches Museum in Vienna and the queen's hair is elaborately coiffured with braids and beads in the same shape as in Klimt's portrait. However, Klimt may also have been inspired by his study of the ancient Egyptian art in Vienna's museums. Whereas most figures of the pharaohs showed their hair descending in parallel lines, one particular one (see Fig. 31), which had been acquired by the museum in 1851, shows the hair or head-dress as a sort of mosaic, very similar to Klimt's fragmentation of the shape into smaller squares, circles, triangles and diamonds. The design is repeated on the far right of the painting, perhaps indicating that it also represents a window, as well as looking back to the Old Masters and ancient art.

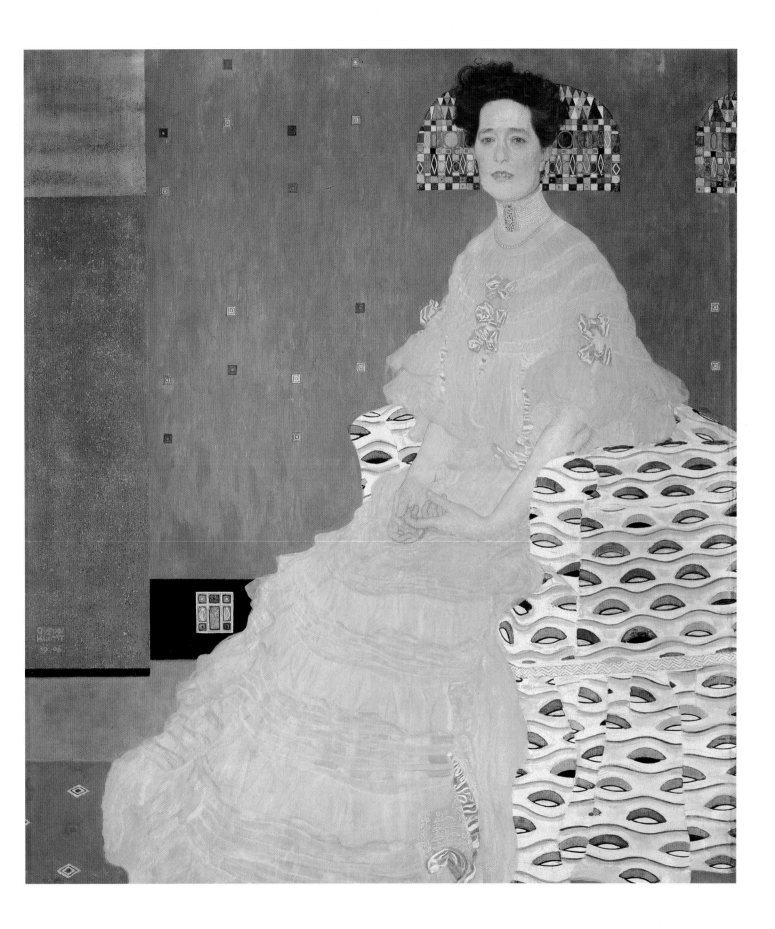

Portrait of Adele Bloch-Bauer I

1907. Oil and gold on canvas, 138 x 138 cm. Österreichische Galerie, Vienna

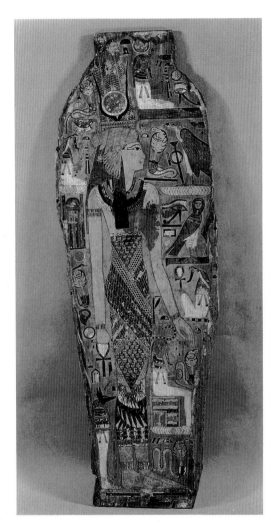

Fig. 32
Lower Half of an
Egyptian Coffin
c1000 BC. Wood, linen,
plaster, coloured pigments
and varnish, h120 cm.
Kunsthistorisches
Museum, Vienna

The influence of Egyptian art on Klimt is undoubtedly at work in this portrait of the wife of the industrialist Ferdinand Bloch-Bauer. He twice commissioned Klimt to paint a portrait of Adele (see also Plate 41). This painting, made at the height of Klimt's career, prompted critics to coin the phrase 'Mehr Blech wie Bloch', a pun meaning more brass (i.e., money) than Bloch.

The portrait is notable for the mix of naturalism, in the painting of the face and hands, and the ornamental decoration used for the dress, chair and background. Like *Judith I* (Plate 15), the way in which the decoration cuts across the shoulders and forearms creates an impression of mutilation. Since Adele, the subject of both of these works, was one of Klimt's mistresses, it is difficult not to look for a psychological reason for the disjointing of the head and body.

Comparison with an Egyptian coffin (Fig. 32) shows much borrowing of motifs. This work entered the Kunsthistorisches Museum's collection between 1824 and 1840 and therefore would have been available to Klimt for study. The eye shapes, the diamonds and triangles of the patterned robes, the necklines and even the colouring of the two images (black, silver/white and red highlights on a gold/gold-coloured background) are very close indeed.

Klimt's study of Egyptian coffins lent ideas for other works. The birds on the coffin may well have been the inspiration for the ones perched in the *Tree of Life* (Plate 32) in the Stoclet Frieze, while his paintings of *Egyptian Art I and II* (see Plate 2) for the spandrels of the Kunsthistorisches Museum, Vienna, are derived directly from his research.

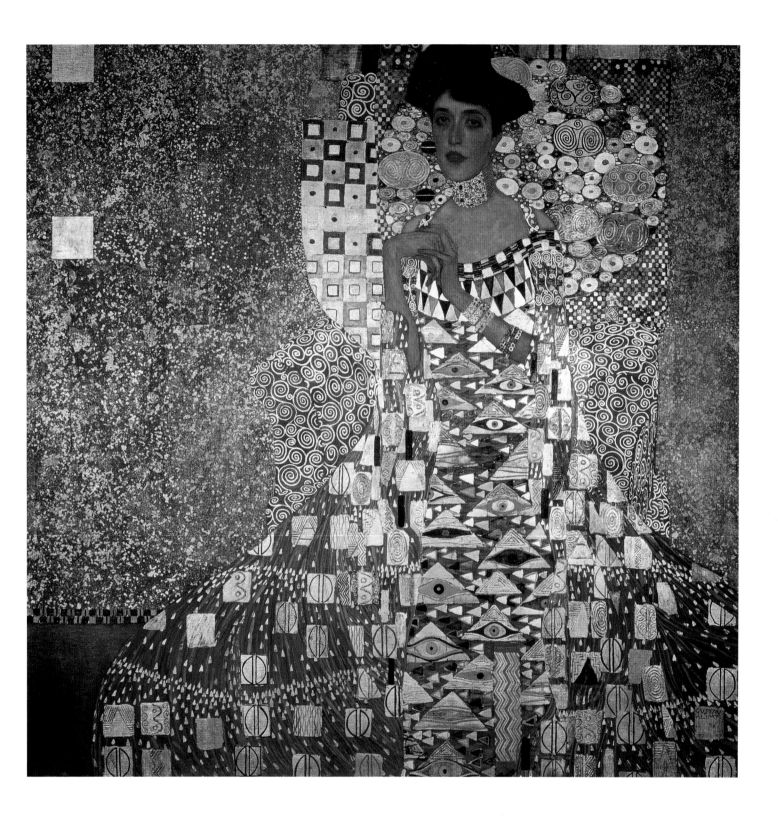

Danaë

1907–8. Oil on canvas, 77 x 83 cm. Private collection

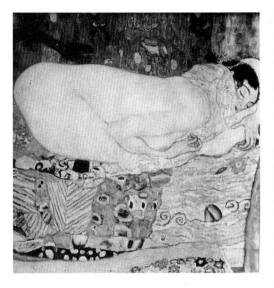

Fig. 33
Leda
1917. Oil on canvas,
99 x 99 cm. Destroyed by
fire at the Schloss
Immendorf in 1945

Both *Danaë* and *Leda* (Fig. 33) are obviously erotic. They show women from Classical myth seduced by the god Jupiter. The sleeping figure of Danaë coils up to meet a fall of golden rain that symbolizes Jupiter. The parted lips and legs, the closed eyes, the rolled-down stocking on her ankle, the red hair and diaphanous purple veil are all indicative of Danaë's sensual experience. Nearly a quarter of the picture surface is taken up by Danaë's thighs, which makes this a highly erotic work.

Leda, painted some ten years later, is even more blatant in its eroticism. Despite the closed eyes, it is unlikely that Leda could possibly be asleep in such a position; rather this is a position of sexual receptivity. The swan has a long history of phallic symbolism, and its snake-like head is predatory to say the least. Leda was the wife of Tyndareus, king of Sparta, and had sex with Jupiter while the god had taken the form of a swan. The resulting children were the twins Castor and Pollux, Helen of Troy and Clytemnestra.

The drawings for these paintings are still more voyeuristic than the finished works. Klimt asked his models to pose in these revealing positions and drew them with simple, clear outlines. The ornament and rich colouring of the painted versions serve to distract the viewer's attention slightly from the exposed poses of the women.

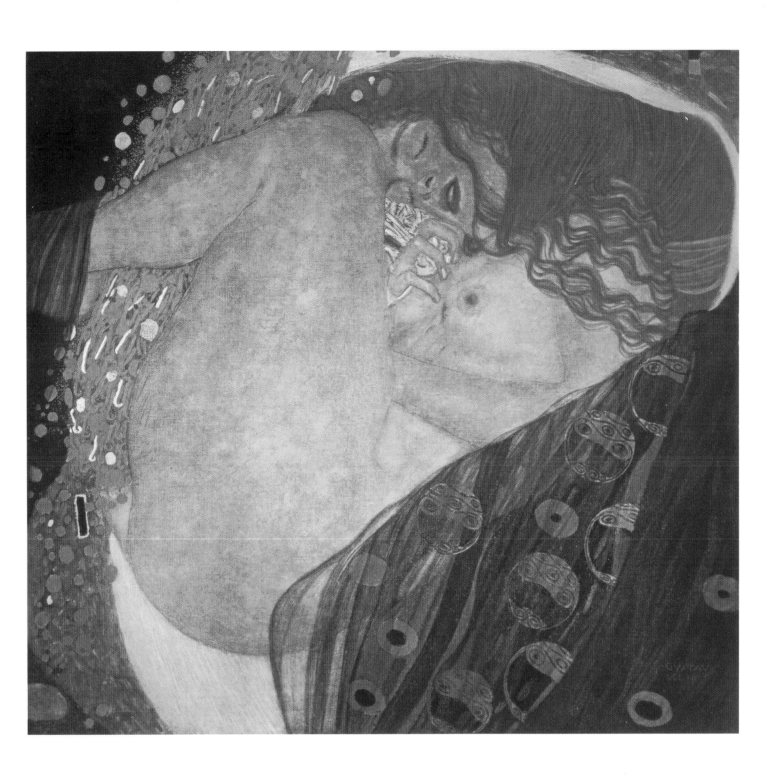

The Kiss

1907–8. Oil on canvas, 180 x 180 cm. Österreichische Galerie, Vienna

Nowhere is Klimt's use of ornament to signify sexuality more important than here, although it had been explored before in *Fulfilment* (Plate 31). The man's form is filled with erect squares and rectangles, while his lover's is composed of concentric circles and spirals. The eventual outcome of such a passionate kiss could hardly be more explicit.

The architect Adolf Loos was strongly opposed to ornament. In a censorious essay called *Ornament and Crime*, published in 1908, he wrote:

> All art is erotic. The first work of art, the first exuberant gesture of the first artist drawing on a wall, was erotic. A horizontal line was a woman lying down, a vertical line was a man penetrating her ... But he who in our age is driven by some inner compulsion to cover walls in erotic symbols, in obscene graffiti, he is a criminal or delinquent ... Ornament is no longer an expression of our civilization.

The Kiss owes much to the Byzantine mosaics in Ravenna that Klimt had seen on his travels. The use of gold for the figures and the background and the fragmenting of forms into small patterns are strongly reminiscent of the mosaic technique.

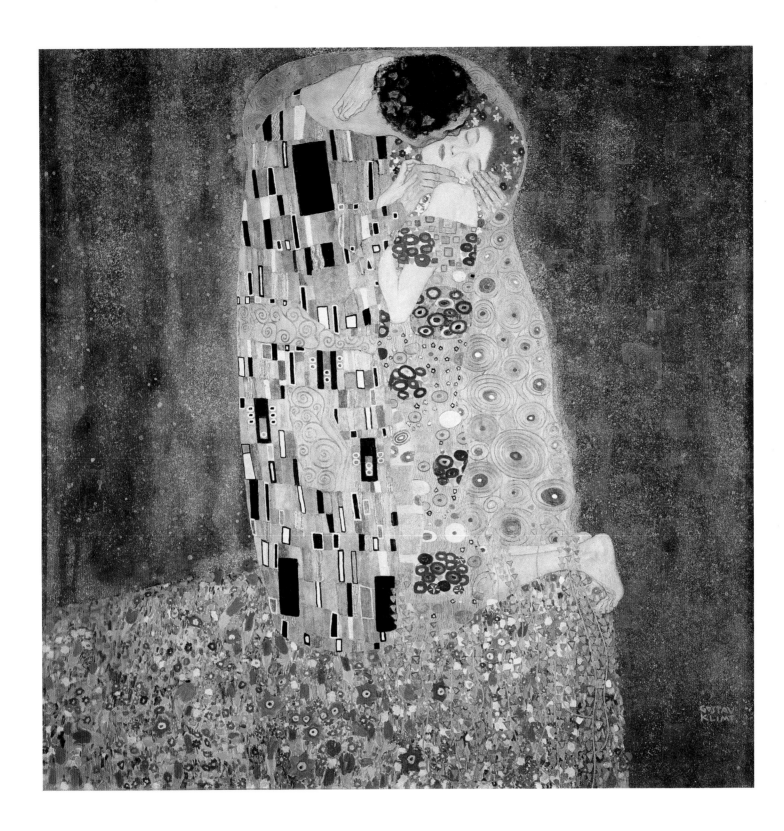

Schloss Kammer at Lake Atter I

*c*1908. Oil on canvas, 110 x 110 cm. Národni Galerie, Prague

Around 1908 Klimt seems to have set himself a new task: to incorporate buildings into his landscapes. He had made two previous attempts to do so, in 1898 and 1901, but from this point onwards they appear frequently. This painting typically includes Klimt's three main landscape elements – water, vegetation and buildings.

Klimt's scenes of houses and villages on the lakeside are similar in certain respects to ancient Egyptian art, as well as to contemporary developments in Cubism. The Egyptians' images of the human body combined the different elements seen from the most recognizable or iconographic angle. The head, for example, is shown in profile, while the eyes are seen from the front (see Fig. 32). Picasso, meanwhile, was distorting the human face in a similar way. Klimt has done exactly the same with his buildings. The houses and two turrets are all presented almost face on, while the roofs are presented as symmetrical triangles, with barely a hint of foreshortening or perspective. The repetition of windows and trees and their reflections locks together the elements of the composition.

Unusually, Klimt has mixed three rather different painting techniques within this landscape, corresponding to the three elements of water, vegetation and buildings. The water is painted with a wet-in-wet brushstroke, so that one colour has been allowed to run into another. The trees and bushes are painted in an almost Pointillist style, with tiny dots of colour delineating each individual leaf. The houses are painted with flat, rather dry strokes, imitating the stone surfaces and tiled roofs of the actual buildings. None of his other landscapes treats the various elements quite so differently, perhaps indicating that he regarded this scene as an unsuccessful experiment.

Judith II

1909. Oil on canvas, 178 x 46 cm. Galleria d'Arte Moderna, Venice

Despite the furore surrounding his earlier painting of Judith (Plate 15), Klimt returned to the subject eight years later. Like *Love* (Plate 3), *Judith II* has a wide frame on either side. As with *Judith I*, the frame is gilded, but the background of the actual painting is no longer gold but a deep, warm, orange-red colour. After *The Kiss* (Plate 36), Klimt stopped using gold to achieve a decorative effect and turned to colour instead. The contrast between the two portraits of Adele Bloch-Bauer (Plates 34 and 41) illustrates the change even more clearly.

As in *Judith I*, Klimt has shown his model with fine, material bindings round her neck, again separating her head from her body. Her torso is partly exposed by her dress, which seems to fall off her shoulders, and her body is cropped by the edge of the picture frame. As in the first painting, the head of Holofernes is dramatically amputated, not only at the neck but also across his face, this time by a swathe of fabric, rather than by the frame. The juxtaposition of titillating nudity and violence is still shocking and the detail of the jewellery, hair ornaments and decorated background add to the uneasy contrast.

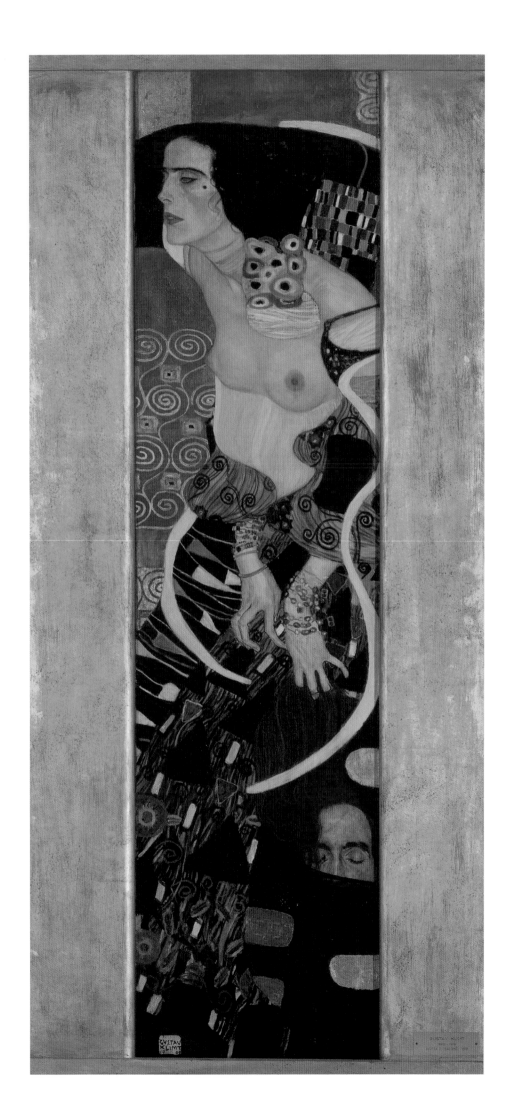

Lady with Hat and Feather Boa

1909. Oil on canvas, 69 x 55 cm. Österreichische Galerie, Vienna

Fig. 34
The Black Feathered
Hat
1910. Oil on canvas,
79 x 63 cm.
Private collection

Klimt produced a few paintings of unidentified women. These were not commissioned works, or else they would have been called 'Portrait of ...', and they are invariably simpler in style. Beautiful women are clad in big hats and feather boas, often wearing furs and muffs. These paintings and sketches probably provided a welcome respite for Klimt. Freed from the need to portray his sitter as a lady of society, with attendant opulence and implied status, he could paint in a looser, brushier style. This work and *The Black Feathered Hat* (Fig. 34) also show Klimt experimenting with soft shades of black – a tone he rarely used in other works.

In both these works Klimt has suggested the sensuality of the women by subtly drawing attention towards their mouths. In *Lady with Hat and Feather Boa*, the boa rides just under her upper lip, while the women in the drawing fingers her mouth in a pensive manner. The red-pink of her hair and lips and the more muted tones of her fingers and cheeks stand out against the predominantly black and white background.

Emilie Flöge's fashion salon may well have been the source for these images. Certainly, contemporary photographs of Viennese women prove his sitters to have been at the height of fashion.

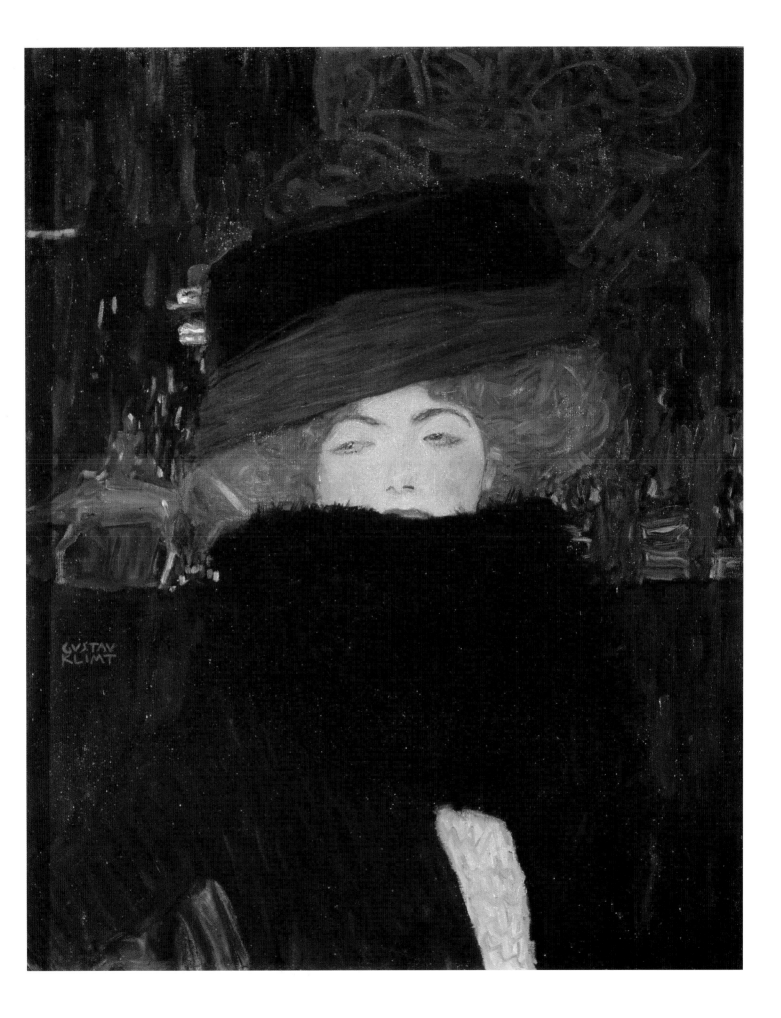

Portrait of Mäda Primavesi

1912. Oil on canvas, 150 x 110.5 cm. Metropolitan Museum of Art, New York

Mäda Primavesi was the daughter of Otto Primavesi, who succeeded Fritz Waerndorfer as financier to the Vienna Workshop in 1914. Primavesi was a keen patron and supporter of art. During the First World War he regularly invited artists, including Klimt, to stay at his country house.

As early as 1912, Otto commissioned Klimt to paint his young daughter, Mäda. Klimt also painted Primavesi's wife, Eugenia, between 1913 and 1914. Klimt had run out of enthusiasm for the heavily ornamented gold portraits of the years 1907 to 1909 and had turned for inspiration to his collection of Japanese prints and art books. Rather than filling the entire picture surface with pattern, he allowed the background to show through much more, enlivening it with motifs here and there. The blossom in Mäda's hair and the birds, fish and butterflies in the rug's design all owe much to the Orient.

Also noteworthy in this portrait is the abandonment of the asymmetrical, diagonally based portrait (see *Portrait of Sonja Knips*, Fig. 12, *Portrait of Fritza Riedler*, Plate 33 and *Portrait of Adele Bloch-Bauer I*, Plate 34). Klimt has returned to the vertical format and symmetry of his earlier works, such as the *Portrait of Serena Lederer* (Plate 12) or the *Portrait of Emilie Flöge* (Plate 23).

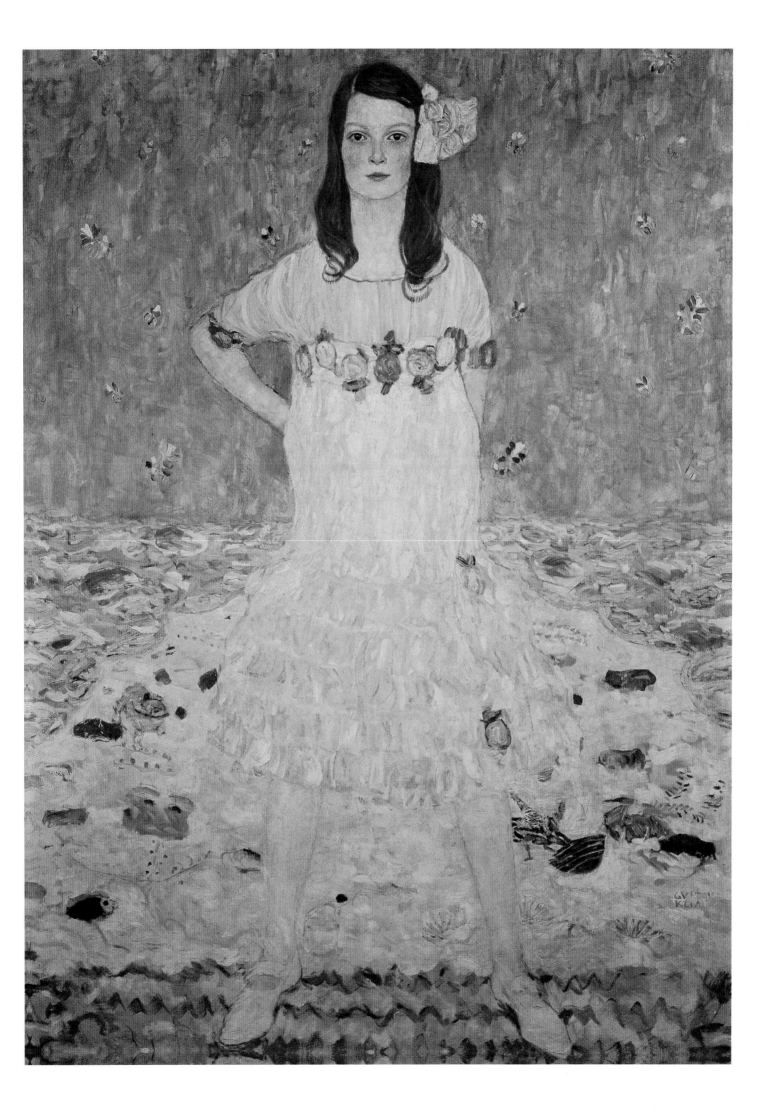

1912. Oil on canvas, 190 x 120 cm. Österreichische Galerie, Vienna

The painting of Mäda Primavesi (Plate 40) was so successful that Adele Bloch-Bauer commissioned a second portrait of herself in the new style. It could not be more different from the first (Plate 34), painted five years earlier. Five blocks of colour fill the background: red, green, blue and two bands of pink. Save for the pink sections, these are adorned with flowers and oriental figures, some on horseback.

In contrast to all this colour and excitement, Adele wears a coat, dress and hat of muted colours, broken only by a dark blue-purple sash at the waist. Her expression seems somewhat remote, unaffected by the exuberance of her surroundings. The wide dark circle of her hat serves to accentuate her face. As already seen, many of Klimt's portraits such as the *Portrait of Margaret Stonborough-Wittgenstein* (Plate 28) or the *Portrait of Fritza Riedler* (Plate 33) make use of a 'halo' or frame around the sitter's face. Perhaps, amid such pattern and ornament, it was necessary to do so in order to satisfy his patrons' requirements.

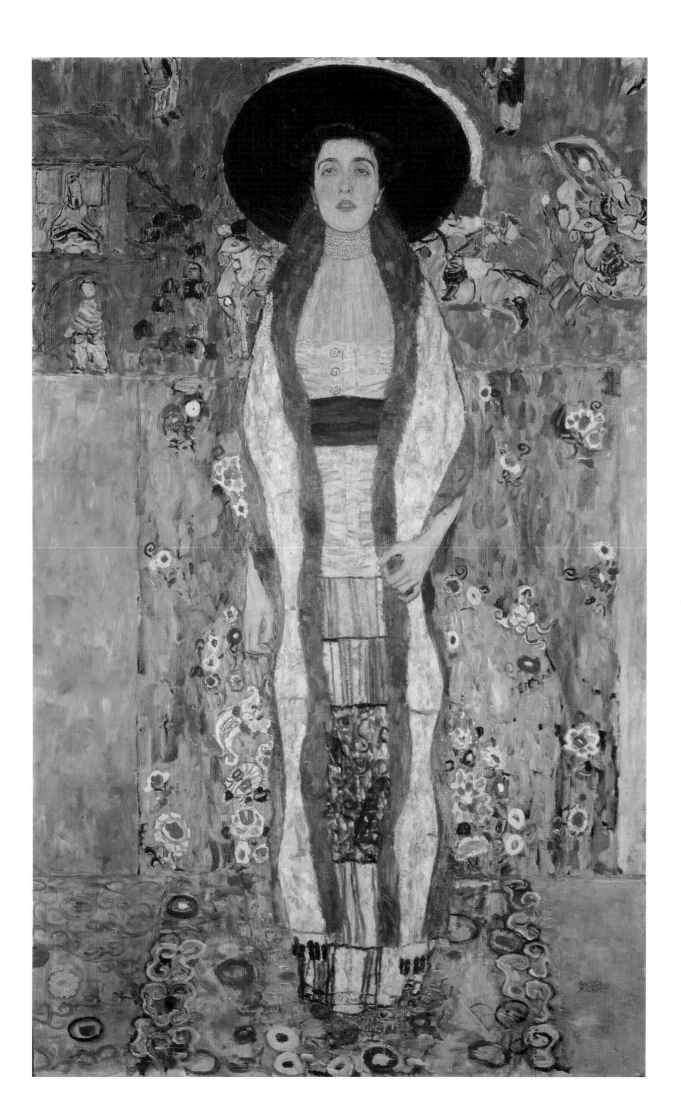

Apple Tree II

*c*1916. Oil on canvas, 80 x 80 cm. Österreichische Galerie, Vienna

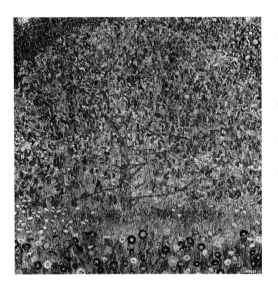

Fig. 35
Apple Tree I
*c*1912. Oil on canvas,
110 x 110 cm.
Österreichische Galerie,
Vienna

Klimt is known to have painted three pictures of apple trees, *The Golden Apple Tree* of 1903 (destroyed by fire in 1942), *Apple Tree I* (Fig. 35) and *Apple Tree II*. It is unclear whether these held any private symbolism for Klimt; however, his repeated attention to the motif makes it likely that he associated the tree with particular qualities. In Christian art, of course, the apple plucked from the Tree of Knowledge symbolizes the Fall. In Greek myth it represents the golden apple awarded to Aphrodite by Paris in the competition for the most beautiful goddess. This apple has come to mean discord, as the choice eventually led to the Trojan War. Klimt may also have been thinking of the golden apples from the garden of the Hesperides, an attribute of Heracles in Greek legend; or from the garden of Freya, the Norse goddess of love and magic. Both these traditions associate the golden apple with immortality. The widely spaced dates of Klimt's three versions, 1903, *c*1912 and *c*1916, make it unlikely that the apple tree held one single meaning for Klimt. While the last may have been painted against the background of the First World War, and perhaps, therefore, refers most strongly to the theme of discord, or fears of mortality, the earliest was painted in untroubled times.

The styles of *Apple Tree I* and *Apple Tree II* differ considerably. The first is comparable with earlier works, such as *Farm Garden with Sunflowers* (Plate 29), in the all-over patterning of colour, in which the lack of sky reduces all sense of perspective, and background leaves are given the same density of colour and definition of line as the flowers in the foreground. *Apple Tree II*, however, is a much looser work. Individual brushstrokes can be seen quite clearly, and the only pattern-making apparent is in the unrealistic outlining of the apples in thick paint, and the solid dots of colour inside.

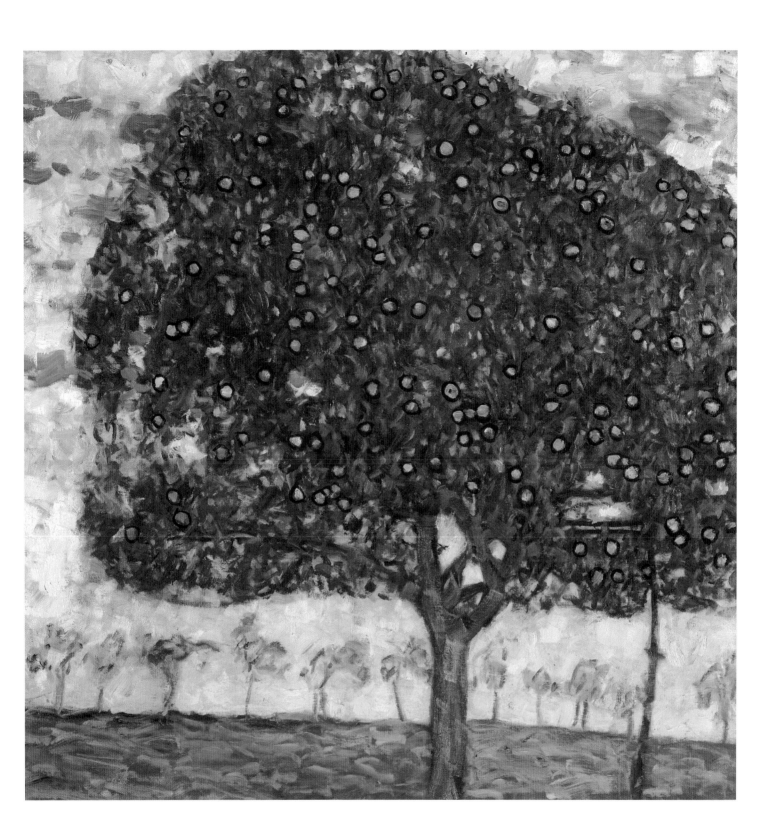

1915–16. Oil on canvas, 110 x 110 cm. Private collection

116

Like the Impressionist Claude Monet (1840–1926), Klimt painted from a boat, returning to his studio to finish the work. This obviously accounts for the viewpoint of this painting, with its reflections in the water in the foreground. At Lake Atter, where the peace and quiet enabled Klimt to paint most of his landscapes, he was the first owner of a motorboat. He also acted as referee in a regatta.

Klimt has made use of the same few colours across the whole surface of the canvas. Thus, in the windows of the house we find the yellows, greens and blue-mauves of the lawn; in the flowers on the lakeside bushes we find the white of the building. This echo of colour helps to soften the transition between the organic forest and the man-made building, while the uniformly treated reflections in the water further unite the different elements of the scene. This is quite unlike *Schloss Kammer at Lake Atter I* (Plate 37), where the different painting techniques sharply distinguish between lake, vegetation and building.

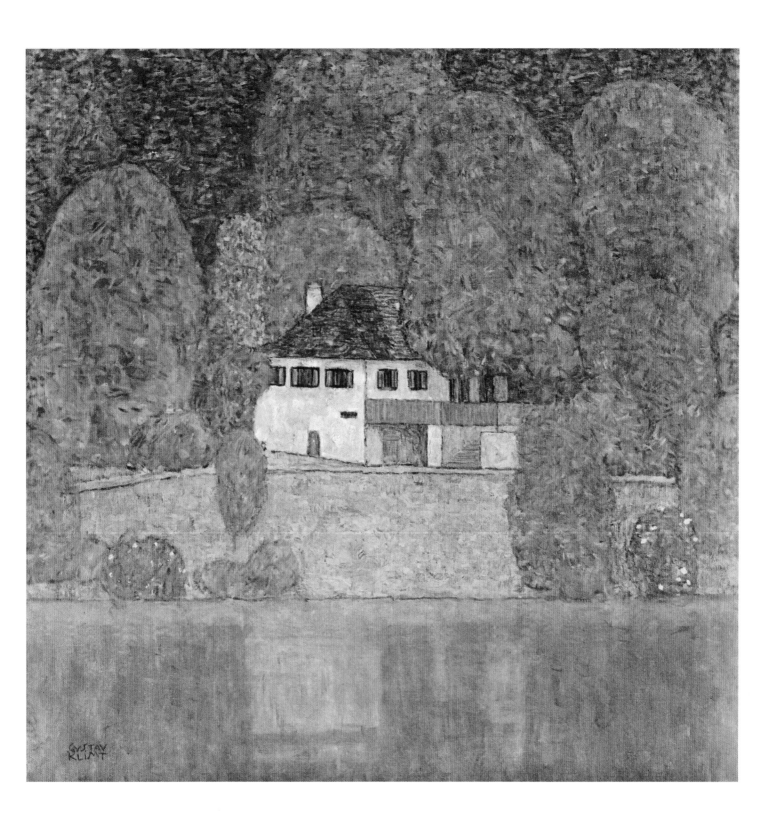

Church at Unterach on Lake Atter

1916. Oil on canvas 110 x 110 cm. Private collection

Unterach, also on the shores of Lake Atter, was the home of some other relatives of Emilie Flöge, with whom she and Klimt stayed. Like the tower of the Schloss Kammer, Klimt dwelt on the church spire of Unterach, with its distinctive onion-shaped dome. As with his other views of lakeside hamlets, Klimt plays with the repetition of simple shapes across the surface of the canvas. The arches of the boathouse are picked up again in the trees above and in the pointed arches of the church itself. The red of the dome is echoed in windows and roofs throughout the picture, providing bright focal points to keep the eye moving across the picture surface. Klimt needed to add these red highlights to attract the viewer's attention since there are no lines of perspective, which usually lead the eye to a vanishing point somewhere on the horizon. Nor is there any sort of meandering perspective of the kind employed by such great landscapists as Claude Lorrain (1600–82), which leads the eye on a wandering path through a scene to arrive finally at a glowing sky. The dramatic frontal positioning of the buildings presents a series of barriers, preventing the eye from rushing off into the distance and encouraging the viewer to look for ways around the trees and buildings. The telescopic effect is similar to scenes of busy traffic in films, when the buildings and cars seem impossibly close together.

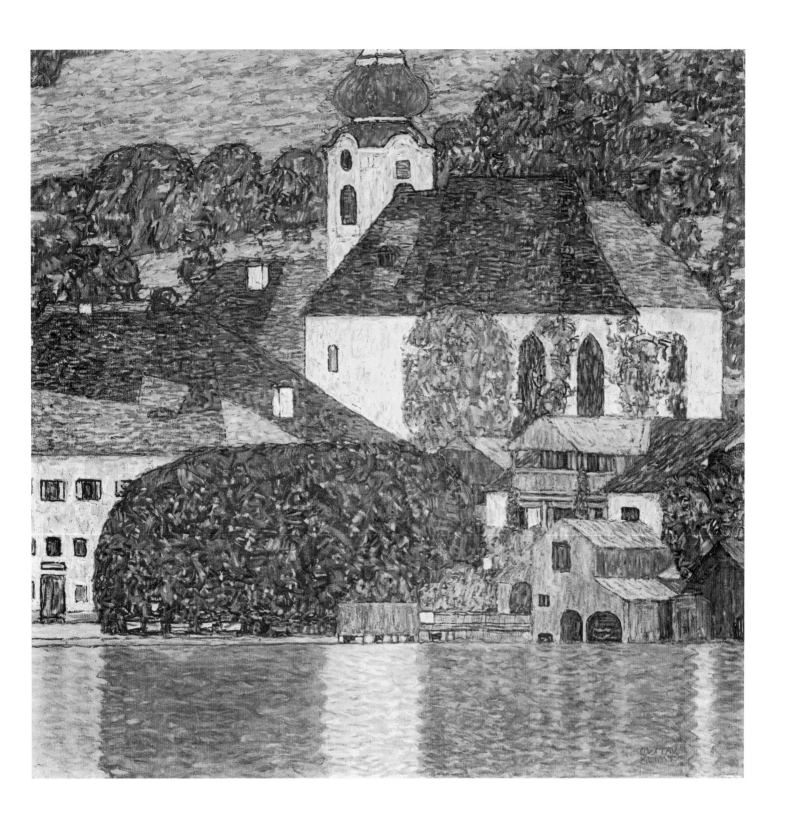

Portrait of Friederike-Maria Beer

1916. Oil on canvas, 168 x 130 cm. Metropolitan Museum of Art, New York

Friederike-Maria Beer had already been painted in 1914 by Schiele, to whom she was physically rather attracted. His portrait shows an angst-ridden figure, bent into a Z-shaped standing position, wearing a zigzag-patterned dress.

Friederike-Maria suggested that Klimt should paint her in a Viennese Workshop dress; she wore these exclusively. She was also very proud of a fur coat she owned, particularly during the hardship of the First World War, and Klimt decided that she should wear the coat too, but inside out, so that the decorative lining, also by the Viennese Workshop, was visible.

Klimt decided to make use of an imaginary oriental screen as a backdrop to her somewhat passive, symmetrical face. The scenes of figures fighting on horseback are taken from a Korean vase owned by Klimt and they are clearly a reference to the First World War. The fierce activity of these artificial figures is sharply contrasted with the docility of the sitter.

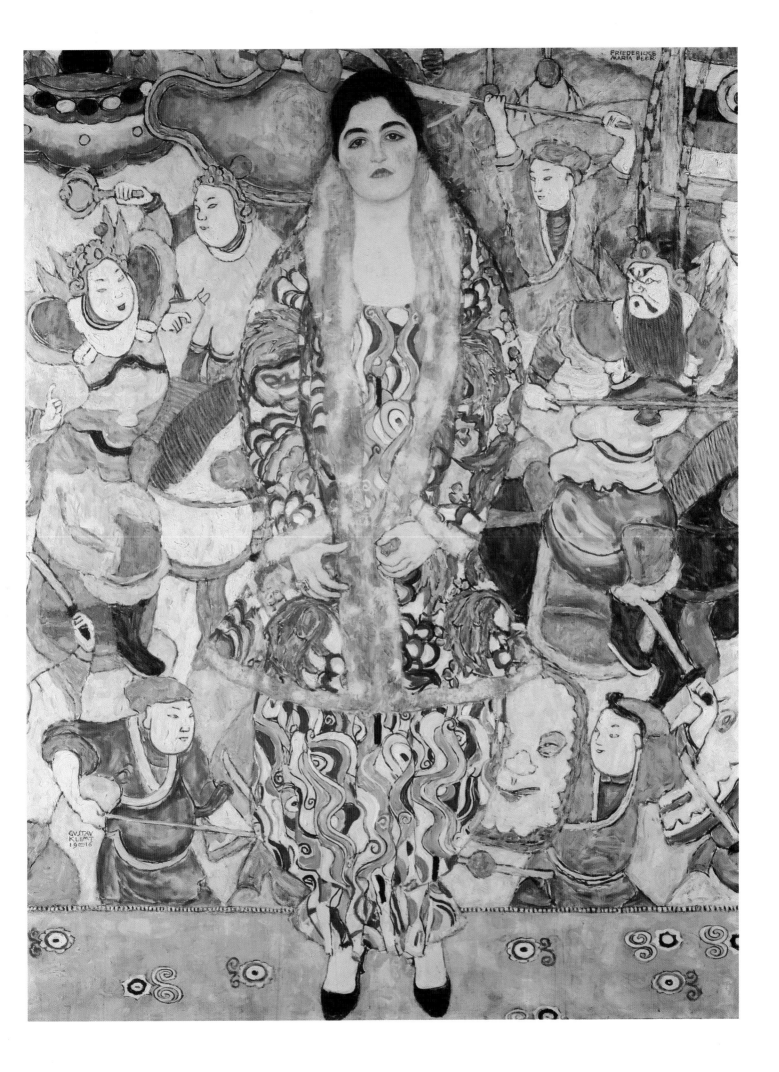

*c*1914–16. Blue pencil on paper, 36.9 x 56 cm. Historisches Museum der Stadt Wien, Vienna

Fig. 36
Embrace
1908. Pencil on paper,
55 x 35 cm. Historisches
Museum der Stadt Wien,
Vienna

Unlike his works for public consumption, such as *Water Snakes I* (Plate 26), Klimt was unhindered by the need for propriety when drawing for his own reference or pleasure. His models are drawn in all stages of undress, masturbating and making love, often offering themselves to the delectation of the viewer. Many of his sketches were used for finished works and numerous preparatory drawings exist for some of his most erotic works such as *Goldfish* (Plate 16), *Danaë* (Plate 35) and *Leda* (Fig. 33).

Lying Nude, however, would never have been destined for display, let alone for a finished painting. Contemporary anecdotes report that piles of loose drawings were heaped all over the floor of Klimt's studio and presumably these were among them. Rumour has it that a dealer anxiously removed several hundred, as Klimt's cats had an unfortunate tendency to urinate all over them.

After the turn of the century, men appear only rarely in Klimt's paintings, for example in the allegorical or symbolic works such as *Adam and Eve* (Fig. 15) and *The Bride* (Plate 48). This does not mean that he stopped drawing them altogether, as *Embrace* (Fig. 36) proves. Men are reduced to a purely sexual role, in a reversal of the early twentieth-century status quo.

Baby

1917–18. Oil on canvas, 110 x 110 cm. National Gallery of Art, Washington, DC

124

This is one of Klimt's few later portraits in which the subject is not standing up. Whereas many of his earlier works show his subject seated in an armchair of some description, all those painted after around 1908 are standing. The only exceptions are due to the age or infirmity of the model. Painting a recumbent baby allowed Klimt to experiment with a totally new composition, placing one geometrical shape inside another. Within the square format is a large triangle, with the baby's head at its apex. The background on either side of it forms two further triangles. The baby's cover is a mass of pattern, in which Klimt's inventive genius has been allowed to flourish, with flowers, spirals, zigzags and rainbow-like arches of contrasting hues. He has also placed contrasting colours next to each other: orange with blue, red with green and yellow with purple. Perhaps the simple fact that the baby's character was not yet formed meant that Klimt felt free to experiment.

The Bride (unfinished)

1917–18. Oil on canvas, 166 x 190 cm. Private collection

Fig. 37
The Virgin
1913. Oil on canvas,
190 x 200 cm. Národni
Galerie, Prague

When Klimt died in 1918, he left several works unfinished, including this one. It provides a valuable insight into the way in which he worked. He would seem to have begun by drawing and then painting an incredibly detailed picture of the bride, with her legs splayed open exposing her genitals. Having completed this to his satisfaction, Klimt then drew an abstract pattern of decorative loops and spirals over the top and started to fill in the shapes with blocks of colour. Presumably, had he been able to finish the work, all we would have been able to see of the bride would be her exposed torso, the rest being covered by a heavily patterned dress.

This begs the question: did Klimt always paint in this manner? Were other pictures similarly explicit under their models' finery? An earlier work, dating from 1912, called *The Virgin* (Fig. 37), may well have started out in this way. It shows a young girl lying on a bed, surrounded by other, more knowing women. Whether Klimt painted these erotic figures and then covered them up so that only he knew that they could be 'undressed' is not clear; he may simply have found that in order to clothe his models as realistically as possible he needed to start with a good, worked-up drawing of the body.

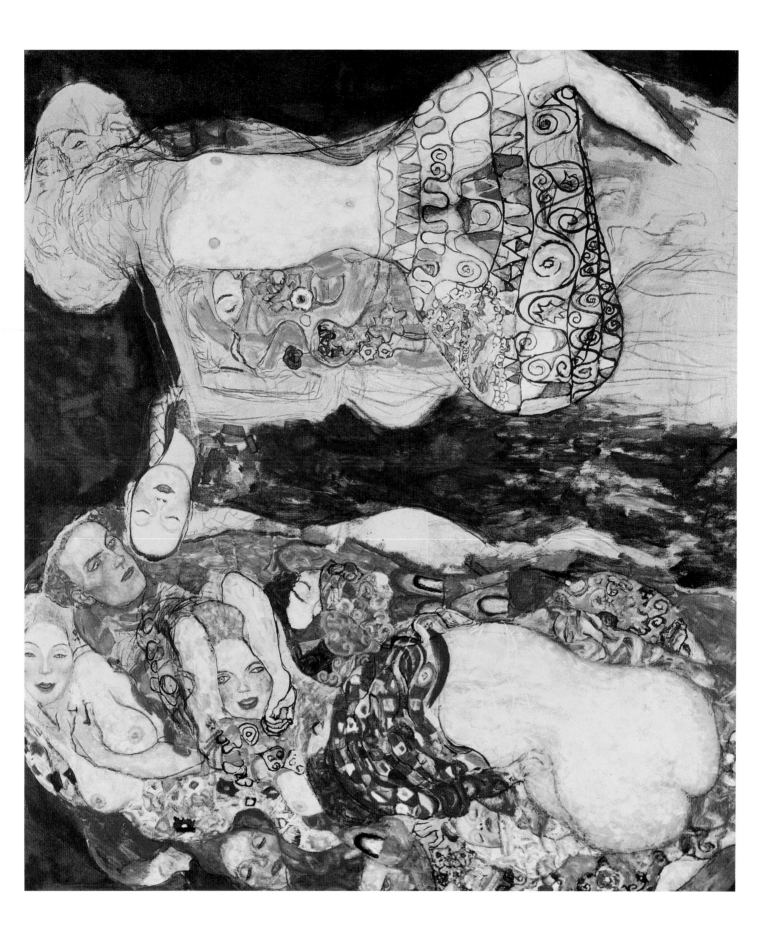

PHAIDON COLOUR LIBRARY
Titles in the series

| **FRA ANGELICO**
Christopher Lloyd | **BONNARD**
Julian Bell | **BRUEGEL**
Keith Roberts | **CANALETTO**
Christopher Baker | **CARAVAGGIO**
Timothy
Wilson-Smith | **CEZANNE**
Catherine Dean | **CHAGALL**
Gill Polonsky | **CHARDIN**
Gabriel Naughton | **CONSTABLE**
John Sunderland |

| **CUBISM**
Philip Cooper | **DALÍ**
Christopher Masters | **DEGAS**
Keith Roberts | **DÜRER**
Martin Bailey | **DUTCH PAINTING**
Christopher Brown | **ERNST**
Ian Turpin | **GAINSBOROUGH**
Nicola Kalinsky | **GAUGUIN**
Alan Bowness | **GOYA**
Enriqueta Harris |

| **HOLBEIN**
Helen Langdon | **IMPRESSIONISM**
Mark Powell-Jones | **ITALIAN**
RENAISSANCE
PAINTING
Sara Elliott | **JAPANESE**
COLOUR PRINTS
J. Hillier | **KLEE**
Douglas Hall | **KLIMT**
Catherine Dean | **MAGRITTE**
Richard Calvocoressi | **MANET**
John Richardson | **MATISSE**
Nicholas Watkins |

| **MODIGLIANI**
Douglas Hall | **MONET**
John House | **MUNCH**
John Boulton Smith | **PICASSO**
Roland Penrose | **PISSARRO**
Christopher Lloyd | **POP ART**
Jamie James | **THE PRE-**
RAPHAELITES
Andrea Rose | **REMBRANDT**
Michael Kitson | **RENOIR**
William Gaunt |

| **ROSSETTI**
David Rodgers | **SCHIELE**
Christopher Short | **SISLEY**
Richard Shone | **SURREALIST**
PAINTING
Simon Wilson | **TOULOUSE-**
LAUTREC
Edward Lucie-Smith | **TURNER**
William Gaunt | **VAN GOGH**
Wilhelm Uhde | **VERMEER**
Martin Bailey | **WHISTLER**
Frances Spalding |